Researching the Arts Therapies

of related interest

Imagination, Identification and Catharsis in Theatre and Therapy
Mary Duggan and Roger Grainger
ISBN 1 85302 431 7

The Glass of Heaven
The Faith of the Dramatherapist
Roger Grainger
ISBN 1 85302 284 5

Drama and Healing
The Roots of Dramatherapy
Roger Grainger
ISBN 1 85302 337 X

The Social Symbolism of Grief and Mourning
Roger Grainger
ISBN 1 85302 480 5

Art-Based Research
Shaun McNiff
ISBN 1 85302 621 2 pb
ISBN 1 85302 620 4 hb

Foundations of Expressive Arts Therapy
Theoretical and Clinical Perspectives
Edited by Stephen K. Levine and Ellen G. Levine
ISBN 1 85302 463 5 pb
ISBN 1 85302 464 3 hb

Handbook of Inquiry in the Arts Therapies
One River, Many Currents
Edited by Helen Payne
ISBN 1 85302 153 9

Researching the Arts Therapies

A Dramatherapist's Perspective

Roger Grainger

Jessica Kingsley Publishers
London and Philadelphia

Grateful acknowledgement is made to Blackwell Publishers for permission to reproduce the material on p.122, originally published in Robson, C. (1993) *Real World Research,* Oxford: Blackwell, pp.451–452. Grateful acknowledgement is made to Routledge for permission to reproduce material by R.Grainger originally published in Milne, D. (ed) (1987) *Evaluating Mental Health Practice: Methods and Applications.* London: Croom Helm, pp.154–160. Grateful acknowledgement is made to Holt Rinehart and Winston for permission to reproduce Figure 4.2 on p.46, originally published in Sheridan, C.L. (1973) *Methods in Experimental Psychology.* New York: Holt Rinehart and Winston, p.73.

The right of Roger Grainger to be identified as author of this work has been asserted by him in accordance with the Copyright, Designs and Patents Act 1988.

First published in the United Kingdom in 1999 by
Jessica Kingsley Publishers Ltd
116 Pentonville Road
London N1 9JB, England
and
325 Chestnut Street
Philadelphia, PA 19106, USA.

www.jkp.com

Library of Congress Cataloging in Publication Data
A CIP catalog record for this book is available from the Library of Congress

British Library Cataloguing in Publication Data
Grainger, Roger
Researching the arts therapies : a dramatherapist's perspective
1.Arts – Therapeutic use – Research 2.Occupational therapy – Research – Methodology
I.Title
616.8'515'072

ISBN 1 85302 654 9 ✓

Printed and Bound in Great Britain by
Athenaeum Press, Gateshead, Tyne and Wear

For Alida Gersie

Preface

This is a book about the way that research is defined and how particular definitions affect our attempt to understand and practise the arts therapies. The author himself is a dramatherapist but his subject concerns arts therapies of all kinds, for this is a book about the aims of research, what it sets out to do and to be. During the last fifty years a good deal of effort has been put into the attempt to understand the arts as media of the healing of persons. There have been attempts to formulate theories about the therapeutic effect of artistic experience, explorations about the nature of artistic communication and schemes for the systematic employment of artistic structures as a framework for teaching social skills. There have been experiments designed to measure the effects of artistic interventions into particular psychiatric conditions and attempts to align various kinds of artistic expression with corresponding forms of emotional or cognitive illness. This range of intentions has involved a range of approaches including, for instance, the use of questionnaires, psychometric tests, case studies, longitudinal histories, projective approaches, attempts at therapeutic criticism using artistic ways of describing events, etc. The following chapters, however, are mainly concerned not with the actual tactics involved in solving problems that have already been marked down for solution but with the research strategies needed to identify them as questions worth trying to answer. They are addressed mainly to those who are affected by the current emphasis on 'evidence-based practice'; who are interested in the idea of carrying out research into the arts therapies but are not specialists in any kind of research and who hesitate to venture into an area widely believed to hold dangers for the uninitiated. If this book encourages arts therapists to find their own way of coming to terms with a subject that is both fascinating and rewarding, it will have achieved its object. Having decided on the research orientation that suits their purpose best, they will be in a position to consult texts of a more technically advanced kind.

Handles

We give thanks for the invention of the handle. Without it there would be many things we couldn't hold on to. As for the things we can't hold on to anyway, let us gracefully accept their ungraspable nature and celebrate all things elusive, fleeting and intangible. They mystify us and make us receptive to truth and beauty. We celebrate and give thanks.

Taken from Leunig, M. (1991) The Prayer Tree, *p.42; published by Lion Publishing and reproduced by permission.*

Artists and Healers

In the following chapters I shall be looking at the kinds of problems involved in tackling research into the arts therapies. Like all books, it reflects the experience and general mindset of its author: I am a dramatherapist. There is more in this book about dramatherapy than there is about the other arts therapies. I think it is wiser to come clean on this point, although I have drawn some of the examples I have used to illustrate various stages of my argument from art, music and dance–movement therapy.

This being the case, it may seem a bit bold, if not downright cheeky, to call the book *Researching the Arts Therapies*. Surely another title could have been chosen which would have been more appropriate – such as 'Approaches to Dramatherapy Research (with some reference to the other arts therapies)'. This would have been to miss the point, however, because the one thing that this is not meant to be is a book about the distinctiveness of dramatherapy research as opposed to other arts therapies' approaches.

The really important aspects of research into dramatherapy are the things it shares with all attempts to investigate subject areas of this particular kind – the kind, that is, which deals with processes that are rational, in the human sense of the word, rather than scientific. This is a book about the shared ground of psychotherapeutic research, an area which includes all the arts therapies and many other approaches as well. It attempts to come to terms with a situation that affects everyone whose purpose is to try and draw firm conclusions about interpersonal encounters.

I would not have written this book if I had not been a practitioner–researcher myself, continually being brought face to face with this chronic dilemma confronting the psychological therapies and struggling to find ways of solving it. The impetus to explore it came from my own personal involvement in it. Certainly it is as a dramatherapist that I am myself involved; but I am quite confident that if I had been an art therapist, a music therapist or a dance–movement therapist, the underlying argument of this

book would have been recognisably the same. Much of the basic material focuses on dramatherapy because it is, quite literally, my starting point or home territory. If I had attempted to give the same attention to the other arts therapies as to dramatherapy, I should have found myself engaged in the task of writing another book altogether – one that I am certainly not in a position to write. I might have edited it, perhaps, but the book itself would have had to be written by at least three other people as well as myself. It would not have been the same kind of book at all.

What follows, then, is one person's attempt to describe a situation that involves, affects and concerns not only himself and his fellow practitioners but other practitioners in fields closely cognate to his own. These research approaches are the ones used by other psychological therapies as well as dramatherapy, and particularly by those which find themselves faced with the same basic research problem as the one facing dramatherapy – that of reaching convincingly definite conclusions in a field where the wrong kind of definite conclusions wrongly applied can be inappropriate and misleading. This is neither a compendium of all available research techniques nor a handbook giving instructions and guidance as to the application of any one approach. Research itself is an immense subject and there is always the danger of giving an impression that the suggestions one makes, however carefully considered, are the only ones that could be made in the circumstances. This book maintains that given the right research attitude – one which clings to the proposition that research is there to help us rather than the other way around – the relationship between circumstances and approaches is often more flexible than might at first be thought to be the case. The aim here has been a comparatively crude, almost simplistic one – that of distinguishing some fundamental research attitudes and the basic models associated with them. Each chapter has a concluding section directing the reader's attention to places where more detailed and specific information may be found, or, in some cases, material aimed at counterbalancing any dramatherapeutic bias that exists within the main body of the chapter.

The argument that it is plausible to write a book about arts therapies research in general from the standpoint of one arts therapy in particular depends, of course, on the degree of shared territory that exists between them; and the present book takes its stand on the proposition that so far as certain fundamental characteristics are concerned, similarities outweigh differences to an extent that makes this kind of undertaking viable – or even necessary – and that these similarities are not only attitudinal or

philosophical in nature but, to an important extent, technical as well. Obviously, having said this, it is necessary to explore the idea in more depth before going any further.

What, then, are the particular characteristics which these kinds of therapy share, governing as they do the kinds of research likely to be undertaken by arts therapists and the ways in which they will approach the task of carrying it out?

Some of the Distinctive Characteristics of the Arts Therapies

Projective Approach

Flowers (1975) points out that all interpersonal psychotherapy uses a dramatic framework in the sense of being a 'staged' encounter. (There are two ways of looking at this – either from the point of view of the specific 'therapeutic frame' described by Milner (1952) or in the more generalised way associated with Goffman's (1990) 'dramaturgical social psychology' in *Frame Analysis and the Presentation of Self in Everyday Life*.) Creative therapy takes the 'presented' nature of psychotherapy into account in order to allow it to be consciously used as a source of healing. Objectifying awareness by giving it an independent existence apart from oneself is recognised by creative therapists as inherently therapeutic. The creative therapies are humanistic in the sense that they locate healing in personal relationship – in other words, in 'what is between' self and other. Thus they value objectified self-expression as a means of making contact with whatever is not the self, bridging the gap of otherness. (Compare the associated ideas of Winnicott's (1971) 'transitional objects' and Fritz Perls' (1973) contact 'cycle', particularly Rollo May's (1975) understanding of the function of art to stand apart and involve at the same time.)

This kind of insight is crucial for any understanding of the creative therapies, which regard art as a medium rather than a technique and the things it creates as presences rather than tools. These things – the musical notes, the finger-painted design or the interplay of bodily movement and room furniture – stand by themselves. Whatever they may mean, or remind us of, or bring into our awareness, they exist as themselves. Certainly we made them, but having been made, or actually in the making itself, they have moved aside. They have moved away from us into the public domain, from where they are able to greet us as themselves, not as parts of us, and lead us *across*. The 'thingness' of the art we create is essential to the way it allows real

relationships. As Winnicott reminds us, the transitional object is not subject to the disasters we fear for ourselves and those on whom we so urgently depend, who are flesh of our flesh, bone of our bone – even the disasters we ourselves inflict on them, so that Teddy can actually be perceived as being more him (or her-) self the more old and worn she (or he) becomes.

Thus although the creative therapies may be said to 'use' the various art forms, they do not do this in the sense that we often mean by the word use. They do not subsume them in any way. In the human attempt to be 'scientific' they may try to reduce them to something that can be reproduced in terms of one's own existing mental schemata, but they are bound to fail because art cannot be used in this sense. It has an innate tendency to keep cropping up when and where you were not actually looking. Because of the effect it sometimes has on you, your reaction to it, it sometimes feels that it is it that is actually using you. Whatever its essence may be (if such an idea has any validity), this is its existence. Phenomenologically, art stands apart from what it is deeply concerned with: because it is a living symbol of relationship and 'betweenness', it can help us in our search for human wholeness.

Projective therapies are avowedly and intentionally reflective. We reflect on ourselves in the light of what we perceive somewhere else. This might be the way we see our world, or crucial components of it, in an ink-blot once we are officially encouraged to do so. It may be the way we see somebody like ourselves in a dramatic role taken by someone who is not us – neither the part nor the actor playing it is actually us. The fact that we know this is a drama allows us to use our imagination just as effectively as if we were urged to do so by a therapist. Or it could just as easily be a pattern of dance, a way of moving our bodies in space and time that triggers our imagination so that it is suddenly more than itself, although we know very well that it is, in fact, itself.

This kind of relationship with a particular art form is the distinctive thing about art therapies as a genre; the characteristic that sets them apart from other approaches, even some of those which include artistic activity in their technical repertoires but look at it in a different way. For example, at least three models of psychotherapeutic intervention involve drama: Kellian 'fixed role therapy', the Gestalt 'experimental' approach and, of course, psychodrama itself. All three regard drama as a tool of therapy in the sense of being a clinical treatment understood and interpreted in terms of the method required by a particular theory of psychopathology to generate material for its own kind of analysis. Instead of allowing the procedures of therapy to be symbolic of another kind of meeting, they 'identify the theory with the

method' (to use Jung's phrase – 1968, p.140). For instance, Blatner describes psychodrama as 'a methodology embedded in an integrated field of psychotherapy that is itself embedded within a comprehensive holistic view of psychology' (1997, p.144); a contemporary authority on Gestalt states clearly that 'the rationale for the integration of these creative means of expression comes from learning theory and holism' (Mackewn 1977, p.150); while personal construct psychology uses drama quite explicitly as a do-it-yourself way of teaching the client how to 'interweave new role-constructs with the fabric of his main construction system' (Kelly 1955, p.410). The arts therapies do not ignore systems of psychological (or psychopathological) explanation, they simply allow artistic expression to stand in relation to such systems and not to become reduced to them – perhaps to be in dialogue with them. (Hence the ongoing debate within dramatherapy about the role of interpretation: Does drama require or simply allow interpretation? Does interpretation 'cloud the theatrical symbol'? (see 'The dramatherapy/psychotherapy debate.' Dramatherapy 19, 2, Autumn 1997, 14–21.) There is no official dramatherapy position on this matter and it would be hard to see how there could be. Some arts therapists are more concerned to establish their place as members of the psychotherapeutic community than others and the deciding factor is most commonly considered to be this question about the specific role of interpretation in therapy.)

The Arts Therapies and Active Imagination

In the creative therapies the difference between 'fact' and 'fiction' is consciously explored. The 'as if' game is played openly. At first sight it may seem that to concentrate attention on music or painting or drama is simply a way of promoting an escapist attitude to a person's pain. Surely, we don't want to encourage patients or clients to spend their time fantasising! Not being able to tell the difference between reality and fantasy impedes our ability to cope with life simply because it makes us that much less intelligible to one another, and relationship depends on communication. Dramatherapy tends to attract this kind of judgement, being the most demonstrative in its exploration of fantasy and using real bodies to do so, but all the creative therapies treat things as if they were personal, channels of personal reality, media for sharing our own personhood with another or others. Like other 'transpersonal psychotherapies' they focus acutely upon the human imagination.

Because they use imagination as a medium for sharing personal experience, welcoming other people into what would otherwise remain private worlds, the creative therapies regard it as an active presence rather than the simple projection of something inside people. How an artistic event – a picture, sculpture, drama, play, musical sequence, etc. – achieved its independent life is something a scientist would find difficult, if not impossible, to explain. The pragmatic fact, however, is that to anyone participating in such an event, even in an apparently passive way, the happening or thing has what can only be described as 'a life of its own'. (Rollo May (1975) has pointed out that it is this kind of liveliness that distinguishes works of art from other human phenomena.) Within the Jungian model of psychic reality, in which the individual unconscious is differentiated from the collective reservoir of unconscious psychic life, the artistic imagination assumes the role of intermediary between persons and the source of their personhood. Jung speaks of 'active imagination' (*Imaginatio*) which we can call on to tell us things about life and death that we have no other way of knowing – things that originate 'outside' the individual psyche. This kind of active imagining, characteristically expressed in art, is a reality and not merely the representation of a reality – 'an authentic feat of thought or ideation which does not spin aimless and groundless fantasies "into the blue", but tries to grasp the inner facts and portray them in images true to their nature' (*Alchemy 160*, 462–463).

Arts therapists are accustomed to regarding their various media not merely as ways of objectifying ideas and feelings or communicating messages that words cannot be found for but as ways of achieving a particular kind of distance from one's current experience – not so that one can abandon that experience but in order to change it by revisiting it from 'somewhere else'. Their way of explaining how this can happen varies according to whether they think in terms of 'transitional objects', 'active imagination' or 'aesthetic distance' and ideas of relationship-through-separation based on Martin Buber.

One example of the latter would be the juxtaposition of separation and contact in dramatherapy's use of theatrical catharsis. This occurs in the confrontation between two distinct perceptual worlds (or 'frames') – the ordinary one 'outside' the play and the imaginative creation within it – which permits an intensified experience of sharing and close personal involvement as the dramatic frame both heightens our awareness of others and calms our

defensive fear of being engulfed by them (or our own reaction to them!) (Duggan and Grainger 1997).

Another example would be dramatherapy's use of aesthetic distance to explore the contingent nature of people's self-images (Jennings 1990). In both cases an art form – drama – provides those taking part with a safe place and time to take risks with the way they see themselves (and see themselves being seen!).

Certainly, to put it like this is to see things from the distinctly theatrical viewpoint of dramatherapy, which is only one of the creative therapies. All of them tend to agree, however, that being healed through this kind of 'image work' involves allowing the image to transmit its own message rather than translating it into another kind of language. Many dramatherapists, for instance, agree with Jung that it is better to 'stay with the image' rather than trying to 'decode' it in any way, its purpose being communication not confusion.

There are differences in the way that individual arts therapies regard research. An overview of published research undertaken during the last twenty years (such as that included in Payne 1993) suggests a tendency for arts therapy to look for validation in terms of closeness of fit with dynamic psychopathology and for music therapy to rely on the kind of precise differentiation which lends itself to qualitative analysis. Dramatherapy, on the other hand, sometimes appears to shy away from both things – interpretation and measurement! However, although it might be possible to align specific 'research attitudes' with individual arts therapies, it would certainly be hard to make this kind of distinction stick because of the presence of so many exceptions, and the fact remains that, in this case, the similarities are so much more important than the differences. Separate disciplines are united by a shared understanding of art on the one hand and healing on the other, and of the relationship which exists between them, and this is what binds them together and distinguishes them from all other therapeutic strategies.

Researching an Arts Therapy

The arts therapies – art, dance–movement, drama and music – confront the various circumstances and considerations which limit and distort our relationship with other people and ourselves, and reduce their power over us. Because they are wholly personal approaches, something happening between people rather than something done to people, they appeal to those who are doubtful about the lasting effects of more customary ways of managing psychological disability. Perhaps they are doubtful because the treatment they have received has somehow made them feel less personal, less real than they did before they became patients, and, since it was their feelings about themselves that mainly needed healing in the first place, they are eager to find a way towards psychological health which regards them more like people and less like objects.

Compared with drug treatment by psychotropic drugs or techniques of behaviour modification which involve processes of reconditioning, these therapies seem vague and 'unscientific', far too dependent for their understanding of themselves on the subjective and intrapersonal aspects of life which doctors may consider important but, in the absence of more concrete physical and behavioural changes, hesitate to regard as scientific evidence of anything in particular. In other words, ideas, feelings, attitudes, intentions, expectations, interpretations – everything which, by its nature, takes place 'within' a person, however meaningful it may be to the person concerned (and, of course, to everyone with whom that person comes into contact) – can never be considered scientifically significant. As for what happens between people, that is a kind of understanding which lies right outside the range of any objective measuring device we possess. What happens between is, and always will be, impenetrably vague.

And yet it is upon this 'betweenness' that science itself depends. Interpersonal science – the study of behaviour – depends upon my observation of you (or yours of me, of course). This is what it consists in. If my

understanding of this betweenness is not helped by my attempts to measure it in the way that I am accustomed to measuring other things, I must find another tape-measure – that is, I must use 'tape-measure' as a metaphor rather than the name of something I can hold in my hand. It must be a metaphor for a different kind of measure and a different kind of measuring. This, of course, is where things get difficult, because the concept of reality which science finds indispensable only concerns tape-measures which are visible and tangible. If, for instance, I want to mark a difference between the ways in which I myself react to two different gestures made by another person or to find a way of distinguishing one person's gesture from the same action made by someone else, I must devise my own way of finding out whether or not the people concerned (myself included, either as observer or participant or both) experienced the kind of difference between the events which we consider significant, because scientific significance refers to differences distinguished by referring to some kind of scale marked off in regular intervals, so that particular degrees of whatever is to be measured may be noted, registered and compared. Obviously, you can't do this for what is really happening between or among people.

A realistic approach does not know where to begin – it simply can't find a small enough interval to base its measurements on. An imaginative approach knows where to begin – you begin between and among. The problem here is how, rather than where.

The problem is always how, of course. Why is a much easier question to answer – at least in a way which satisfies scientists. Something happens because a particular set of circumstances (or 'variables') combine to make it happen. Situations cause events. This means that if one can discern a change taking place in anything or anybody, one can discover why it is doing so simply by looking closely at the situation in which the person or thing is involved. If the situation has changed in any way, that explains why the person or thing has changed. The first event has caused the second. It 'stands to reason', as they say. Science explains events in terms of something changing at the same time as something else and somehow carrying it along with itself. Applied to the study of human experience, this is most clearly exemplified in behaviourism with its doctrine of 'mere contiguity', according to which sentient creatures learn merely by being brought into contact with a part of the environment which acts as a stimulus producing behavioural change. Behaviourists are emphatic that nothing whatever happens between stimulus and response – thought, feeling, memory,

intention are otiose. Something or other produces a change in a person, thing or situation to make it or them a stimulus for change to occur in another person, thing or situation and that is both why and how all change takes place.

It may be why but it cannot really be how. Or rather, it can only be how if we are unable or unwilling to look any closer. Certainly, this may involve evolving theories which are harder to test than the behavioural one. Unless we are willing to do this, however, we may find that we are reducing what we want to know to what we are able to measure – which may turn out to be not what we really want to know at all! Sometimes, we have to learn this the hard way. Later on I shall be describing an investigation that an associate and I carried out into the effect of dramatherapy on people whose thinking had been categorised as disordered (by which I mean unsystematic, tending not to stay with an argument long enough to reach a conclusion). From one point of view, the investigation was successful – not only did it produce a recognisable result but it was the one we were hoping for. At the time, it seemed enough to be in a position to demonstrate the truth of our thesis: 'Dramatherapy alters the way in which people look at the world, themselves and other people, and its results may be studied by examining changes in behaviour and perception which take place as a result of things which happen to the individual within the dramatherapeutic situation' (Grainger 1990, p.99).

Looking at the investigation now, I think we were justified in feeling a certain amount of satisfaction. Certainly, we had managed to show that the people in our sample had become less thought disordered during the period of time that they were attending the dramatherapy sessions and to demonstrate that, statistically speaking, this could not be considered to be the result of chance. In other words, in scientific terms there was a causal connection: the therapy had caused the change. All the same, we were not completely happy with the investigation. We had done what we set out to do but it still didn't seem quite enough. As I wrote at the time, 'The "unscientific" aspect [of the investigation] is the inability of the method to be specific about the precise conditions under which such changes occur, so that these conditions may be exactly reproduced and change reliably predicted' (Grainger 1990, p.99).

Yes, indeed. The fact is, of course, that using a method designed to compare the outcomes of two or more conditions, 'experimental' and 'control', it is not possible to draw conclusions about what is actually taking

place within an experiment. Change happens, or doesn't happen, because of the effect, or lack of it, of the experimental circumstances upon something, or someone, brought into contact with them. The study I had called 'The Use of Dramatherapy in the Treatment of Thought Disorder' would have been more properly described as the effect of dramatherapy on thought disorder. By adopting the kind of experimental design which contrasted an experimental condition – thought disorder plus dramatherapy – with a control condition – thought disorder without dramatherapy – I had committed the investigation to answering the question 'why?' in terms of outcome rather than process. The study was henceforth limited to measuring the effect of one particular circumstance – the presence of dramatherapy – on the experimental subjects – the men and women suffering from thought disorder. If I wanted to find out how dramatherapy brought order into their thinking, I would have to think more effectively myself and design an altogether different kind of experiment.

James Maxwell (1996) puts it like this: 'Quantitative approaches are powerful ways of determining *whether* a particular result was causally related to one or another variable, and to what *extent* these are related. However, qualitative research is often better at showing *how* this occurred' (p.59). The kind of research I would have to do to try to understand what was happening in a dramatherapy session would be qualitative rather than quantitative. This is very important. As a dramatherapist, I would be aware, for a whole range of non-scientific reasons, that something was indeed happening in the dramatherapy sessions, something which I believed to be therapeutic, and my main concern would be to find out more about the ways in which it was happening. I would want to do this in order to learn how to maximise their effects so that dramatherapy would become more healing than it was. Others, however, might not share my particular point of view in this. They might be more concerned to discover whether, in fact, anything at all was happening of a therapeutic nature, in which case they would prefer a quantitative research tool to a qualitative one. We are not interested, they would say, in examining processes which lead to particular outcomes – it is the outcome itself that we are concerned with. How much actual change does dramatherapy produce and is it in the right direction?

For this reason – and it is an important one – dramatherapists cannot afford to abandon quantitative approaches, even though they may sometimes run the risk of looking in the wrong direction in their search for definition,

preferring, as they do, things that are measurable even if they may not be the really important things, the things that actually make something work.

Our experiment did at least do this. So far as its ability to throw any light on the actual process of dramatherapy, it was not so successful. Like the man in James Maxwell's story, we were engaged in searching for our keys under the street lamp, rather than where we had actually dropped them, because the light was better there. Outcome studies were more precise, more measurable, and that is where we directed our gaze. We settled for clarity, even if it showed us what we already knew and did not really want telling. Others, however, needed to be told, and still do. The main justification for carrying out quantitative research in dramatherapy, in our opinion, is to convince the sceptical that it can produce a measurable degree of healing change in psychologically disturbed and vulnerable people. There are still many who need convincing about this. To many people, the word 'drama' implies something either superficial and not worth the consideration of serious students of behaviour, or dangerously misleading and inauthentic, involving the substitution of the sham for the real. Spencer, Gillespie and Ekisa (1983), for example, attempt to demonstrate the therapeutic effectiveness of social skills training and use 'remedial drama' as a control condition in the experiment precisely because it is not expected to produce any effect on the experimental subjects. ('The procedures involved in the control treatment should, at least, appear to be valid so as to generate positive therapeutic expectations' (p.165). One of the authors made this quite clear when, in a verbal statement about the investigation, he remarked that the drama had been chosen 'because it was less likely to affect outcome than simply leaving patients alone in the hospital environment'.) Owen Hargie and Mary Gallagher (1992) select role-play as the opposite of what they call 'genuine' counselling, arguing that what Rogers himself calls genuineness would not be possible in a dramatic scenario.

These are just two examples – the first of drama regarded as non-serious, the second of the state of mind which assumes it to be in some way fraudulent. It seemed to us that the only way to remove this kind of bias, which prevents scientifically trained people from taking therapeutic drama seriously and giving the kind of attention to it which would be genuinely scientific, is to demonstrate these effects in as rigorous a way as possible – hence our quantitative thought disorder study. This does not mean, however, that quantitative approaches are to be recommended for purposes other than that of convincing the sceptical in the most effective way possible.

Dramatherapists need to know what is happening in the dramatherapeutic process for their own sake – and also, of course, for that of their clients. Although the method we used made it necessary to ask people to make judgements and tell us what these were, this was to help us estimate the degree of thought disorder they were showing and took place outside the limits of the dramatherapy process, which was painstakingly preserved from any suggestion that it was part of an investigation. In other words, those taking part had no chance to reveal their own thoughts and feelings about taking part in an experiment. How could they? They were never let into the act, so they didn't really know what was going on. As for us, we only knew what they were able and willing to tell us about the dramatherapy itself.

It seems to us now that this was an unsatisfactory state of affairs. It is not only the process that must be shared but our attempts to understand it too. This means finding other ways of looking at the medium, ways which do it justice as a unique vehicle of human understanding of self and other. Art therapies are notoriously hard to evaluate. Art, more than anything, happens between, in the place no one can measure directly or compare with any other. It communicates its meanings intuitively rather than propositionally, indirectly rather than head-on. Consequently, it is extremely difficult to be precise about its effects. Art has many effects, certainly, but its purpose is to be itself. Art therapists, dramatherapists, music therapists and dance and movement therapists hold that the selfhood of art is therapeutic. Art is healing in itself. This is an understanding they all share. The particular art form which concerns them is valued because of its healing purpose – healing is what it is, not simply one of the things it does, something it can be used for. Art therapists are people who are aware of a truth about art concerning its essential nature or identity. They celebrate this truth, which is always implicit in artistic expression and actual works of art but has been neglected by professional healers and those who decide what constitutes healing. In fact, however, so far as the healing of persons is concerned, anything that allows or encourages the genuine meeting of selves in the encounter that promotes life is a healing event. Art is the celebration of the encounter.

It takes more than talk, particularly this kind of talk, to convince others, however. What Gersie (1996) has written about brief dramatherapy is true of arts therapies as a whole. For this kind of approach to receive the attention and respect it deserves, 'its efficacy as a health-supporting and a health-inducing treatment must be reliably evaluated on an ongoing basis ... Demonstrable links between relatively permanent change and particular

dramatherapeutic activities require further examination, whilst those changes that can be attributed to the interpersonal transactions between the client and the dramatherapist need to be illumined' (pp.18–19). As for dramatherapy, so also for art, music and dance–movement therapies – to convince those who, for reasons of survival in a competitive market, must be convinced that 'further research is necessary'.

It must be the right kind of research, however. This means that it should be carried out for the right purpose, which is to increase our understanding of what is actually happening in the processes we are studying. We are used to identifying purposes by measuring effects. Indeed, in our culture the only way we can demonstrate anything at all is by deciding what is most appropriate to measure about it. We find ourselves doing this whether we want to or not. Perhaps we start by measuring inappropriately, measuring the wrong things, producing a detailed pattern of something else, something resembling our experience but not quite fitting it. We've not quite got it, there's something missing. What's missing, of course, is the event itself, its unique essence. Somehow, this has slipped irretrievably away. This is the central problem facing research into any of the arts therapies. In the effort to be scientific we run the risk of destroying whatever it is that we are being scientific about. It is associated with a rather negative view of research, as something we have to do in order to establish scientific credibility ('lab. cred'?) so that we can become 'mainstream' rather than 'alternative' healers. In our culture this seems to be necessary, perhaps because art seems to be such a non-medical thing and healing belongs unquestionably to medicine. In other kinds of research involving people, including medical research, this has shown itself to be something of a dead end. There is nothing to be gained from drawing conclusions from a method of approach that leads you away from the thing you are studying. It is no good for learning about people and, therefore, no good for understanding art, the essence of personhood (Maxwell 1996).

This is a fascinating challenge and all the arts therapies are involved in it. As time goes on, each of the therapies will find itself needing specialised help as new problems emerge and new research difficulties have to be overcome. There will be new things to be discovered about the therapeutic nature and function of art which do not directly concern experimental design and methods of assessment. For instance, work will have to be done to clarify the therapeutic epistemology of artistic experience. These will be fascinating and stimulating questions and there is no reason at all why they should be studied

by individual therapies in isolation, each profession working by itself, stubbornly pursuing its own course.

This is very important. Despite differences of philosophy which reflect their personal circumstances, the arts therapies have something in common that distinguishes them from any other therapeutic approach or treatment modality. They are about art. A human phenomenon that is peripheral to other approaches, if not actually despised by them, is central here. An artistic attitude does not affect their approach. They do not deploy their forces in an artistic way or explain their therapeutic function or effect by means of an artistic metaphor. They experience art and are healed by it. If they do not always get on together as well as they should, sometimes seeming less than keen on one another's company, it may be because they are young. Also, life has not always been easy for them.

The National Arts Therapies Research Committee aims to be an autonomous organisation consisting of registered Art Therapists, Drama-therapists, Music Therapists and Dance Movement Therapists with a mutual interest in research developments in Great Britain; it aims to seek and establish the furtherance of research development within the professional Arts Therapies organisations.[1] This, of course, is going to need a high degree of co-operation among the professions, particularly when it is spelt out in terms of intention to exchange information about ongoing research projects, upholding and protecting standards of professional research and sharing information on professional and related matters. The rules and regulations limit themselves, quite properly, to shared research. They do not refer to the more obvious aim of fostering relations between the professions. Without success in this area, there cannot be any shared research at all and no point in having committees.

The fact is that the arts therapies professions do not form anything like the natural grouping that one might expect them to do. They certainly have a lot in common so far as their approach to therapy goes, and the similarity of therapeutic medium is reinforced by the fellow feeling that is bound to proceed from hostility and rejection, real or imagined, on the part of more scientifically orientated approaches to healing. However, hostility breeds hostility and professions that have had to fight hard for recognition are not

1 The National Arts Therapies Research Committee is based at the Birmingham Centre for Arts Therapies, The Friends' Institute, 220 Moseley Road, Birmingham B12 0DG.

always willing to welcome newer arrivals who appear to be expected to share the spoils of victory without having borne the heat of the day. The fact that there are, at present, four separate arts therapies and four independent professional bodies suggests that the differences among them are regarded by their members as being as important as the similarities, and, indeed, there are important divergences of theory and praxis which give rise to a certain degree of mutual defensiveness.

All these things suggest that the kind of co-operation aimed at by the Arts Therapies Research Committee may be hard to accomplish. Opportunities for rivalry and consequent disagreement can occur at two main levels: between the professional bodies and between individuals actually carrying out research projects. I have a feeling that there is more hope from the latter than the former. After all, research in these areas is particularly difficult and one needs all the help one can get! The fact that so many research problems arise in an area occupied by all the arts therapies, one that is specifically associated with artistic reality, will make anything other than the very closest co-operation among the individual professions totally impracticable.

This being the case, the importance of the part being played by the Arts Therapies Research Committee cannot be overstated. The first moves in the foundation of the committee came from music therapy at the Fourth Music Therapy Research Conference on 27 February 1988, where it was proposed that a joint conference should be held to consider research developments within all the arts therapies. This took place in March 1989 at City University, London. The original ideas from which the proposal came are attributed to an art therapist (Andrea Gilroy) and a dance–movement therapist (Helen Payne), so it seems to have been a joint effort from the beginning. And so it has continued to be.

The aim of this book is to present an overview of the investigative approaches which are available to dramatherapists interested in carrying out research into their own treatment modality, in the belief that such a book will prove useful for arts therapists of all kinds – or, indeed, for anybody attempting to navigate the dangerous passage between the Scylla of statistical rigour and the Charybdis of experiential inconclusiveness in the ongoing quest to find ways of understanding process without losing sight of the need to measure effects.

In the next chapters I will be looking at quantitative research methods as these have been applied to dramatherapy.

Reading List

Goodwin, C.J. and Smyth, T.R. (1996) *Research in Psychology: Methods and Design and Writing in Psychology: A Student Guide.* Chichester: Wiley.

The Outline of Research

Any kind of research involves making decisions in seven specific areas:

1. Locus – what area of life or the world is to be considered?

2. Focus – what is it we want to find out about this? What are our questions?

3. Strategy – what is the best way of approaching our locus in order to ask our questions?

4. Method – how are our questions to be formulated?

5. Data collection – how do we collect and store our answers?

6. Analysis – how do we arrange the answers in order to extract as much useful information as possible?

7. Reporting – how do we present our findings to others? What effect do we want them to have?

Locus

The need to make up your mind what kind of thing you want to find out more about is obvious – obvious enough to be overlooked in your determination to be as systematic as possible in carrying out prescribed research procedures. This is the very basic stage of research; you must know what it is that interests you before you start looking for examples to observe and examine. In some cases, of course, the locus of research is obvious and your interest in it is decided by its obviousness; it is the state of affairs in which you are already involved and the task of understanding it is, or refers directly to, the job you are employed to do. In other situations, however, you may find you have more scope for making a personal decision about the area you want to investigate. Again, the locus of research may be negotiated so that some kind of compromise is reached between your own inclinations and interests and

those of the people you are working with or for. Perhaps your ideas are influenced by research you have either studied or actually carried out yourself, so that your choice of locus is largely determined by prior experience of some kind; perhaps you are attracted by an area which does not seem to have attracted anyone else's attention, which you feel you can make your own by looking at it in a serious and focused way. Whatever your reasons may be for choosing an area as a potential locus for research, they are worth recording so that you can bear in mind the position you started from and recapture the enthusiasm that led you to undertake a task which, if it is done properly, will turn out to involve a great deal of hard work and, probably, some real boredom as well.

All this applies to corporate research projects as well as individual ones. In these circumstances decisions may be either harder to arrive at – because there are more people who have to make up their minds – or easier – because those who are uncertain may be persuaded to throw in their lot with the majority; or, better, a consensus may be achieved that is acceptable to everybody and can be embraced wholeheartedly because it represents a joint opinion. On the whole, however, the situation is greatly simplified by having the research locus delivered to the researcher by some person or persons in authority, so that the decisions to be made concern the conditions under which research will take place within the designated area – a process of negotiation rather than simple choice!

If, however, the choice is yours and you can literally start from where you want, this is an opportunity not to be missed because of all the advantages you possess when you are 'on your own ground' and can use all the experience, expertise and background knowledge you have acquired in a sphere of life where it will be particularly relevant. Researchers who make their own decisions in this way often have a very practical reason for their choice of locus, one concerned with their work as practitioners in a particular field. What can be done to shed more light on the processes involved and make them more effective and rewarding, from several points of view? Problems and difficulties that experience has made all too familiar attract efforts to discover new ways in which they can be surmounted and provide plenty of opportunities for intensive study. This is 'practitioner research', distinguishable from the kind carried out in laboratories or rigidly controlled and structured clinical settings. The understanding and expertise involved are part of the research background – a principal reason for the selection of a particular locus for research rather than constituting an immediate part of the

research process itself, what we shall call the focus of research. When the locus of research is decided by something other than the professional involvement of the researcher, the role of background knowledge is principally to establish the investigation as a legitimate part of an ongoing debate on a specific subject; the research agenda has already been set and any information supplied by the researcher is directed towards the solution of a specified problem. Only in practitioner research does this background knowledge really belong to the researcher, who fits the research area to it instead of the other way round.

Using background information as a way of identifying locus, then, is associated with research designs which draw on personal experience rather than specialised academic material, as in research which uses quantitative data as its main criteria for measuring success. People who are eager to investigate their own social reality, whether personal or professional, ascribe greater value to 'real-life encounters' than to the rarefied behaviour of experimental subjects observed under experimentally controlled conditions. I shall be saying more about this later on but it is mentioned here to draw attention to the particular importance that background knowledge and personal life experience can have in choosing the general area for research. To this extent, the locus of a piece of research depends on its original provenance – is it initiated by the researcher, the agency for which he or she is employed, or by current academic or professional pressures? Is the data quantifiable in a scientific sense or is it the quality of the experiences to be examined that it must concern?

From whichever angle you decide to look, you must first of all decide what kind of phenomenon you intend to look at. And even though the evidence you are interested in may be drawn from your personal experience, you will need to draw on other people's experience – written or otherwise – to put your own into some kind of perspective. Only thus will your choice of research focus be at all realistic.

Focus

Finding out what you want to know more about and deciding what questions you want to ask go very much together. A problem area is defined by the questions it poses and the process of research is concerned with identifying problem areas. In many cases you will be drawn to a particular research subject precisely because it presents you with a question which you cannot answer without taking the trouble to investigate it properly. You know what

question or questions you want to ask and can immediately start working out the best way of asking it (them). This is usually the case with traditional research questions which are formulated in ways that will require as clear an answer as possible. If what you want to know can only be expressed in a vague or indirect way, you may have to alter your original question to one that this kind of research will find easier to answer.

Alternatively, of course, you may decide to use a different kind of research approach, one in which the process of arriving at the questions to be asked itself forms part of the research. If you want to understand something more clearly but are not sure what it is that has to be understood about it, your first step is to investigate the kinds of questions regarding it that might possibly lead to greater understanding. In this case research into answers is preceded by research into questions – obviously a fundamental stage in the overall research process but one that the traditional approach has neglected or overlooked. Whichever way you choose, the more thoroughly you explore your subject area the easier you are going to find it to make up your mind about which questions to ask concerning it. Knowledge of locus allows decisions about focus! If your research involves deciding what questions to ask, this, too, should be demonstrated as publicly as possible. There are various ways of doing this, all of which involve opening the subject up to other people. Remember, at this stage you can afford to ask as many questions as you want without having to settle on any one form of enquiry. The process of decision is part of your research, so that the questions you finally ask will be ones whose relevance has been asserted in the course of argument and discussion. Even more important than this, they will be the things you yourself have discovered a real need to know.

'Exploring for focus' does not mean staying rigidly with the locus of your original research interest. In fact, this focus broadens as you start looking at it properly; the action of focusing suggests other focus points, some of whose surrounding locations may need to be taken into account at this stage. Other people's research in similar areas, presenting similar kinds of difficulty, should be considered, as well as research in general – the kinds of problems that arise whenever we try to understand this with any real clarity, some of which I shall be looking at later in this book. Other people's opinions play an important part in the process of arriving at your own considered view of the problem or problems facing you (Delbecq, Van de Ven and Gustafson 1975). The most important thing about this kind of research is that it should proceed from a genuine need to know on the part of those carrying it out and

not from a desire to produce a neat behavioural experiment in which awareness of the kind of answer likely to be considered acceptable played a large part in deciding the question or questions to be asked. On the other hand, the kind of question asked must be one that you know to be potentially answerable, even though at this stage you are not sure how the answer is to be obtained. Group discussion and 'brainstorming' often produce ideas for questions which we have never thought of answering before and these are the ones that are least likely to suggest familiar or stereotyped answers. They are questions that have arisen in the course of your search for the truth about a state of affairs in which you are personally involved. They do not represent a 'decision to do research' but a need to know something which only research can reveal. The way you plan your research will reflect your determination to remain true to the actual question as it first presented itself to you. It is your question and the strategy adopted will be yours too.

Strategy

Research strategies may be classified under three main headings: case studies, surveys and actual experiments. In a case study the aim is to find out as much as possible about the behaviour and experience of individuals and the circumstances giving rise to this (hence the commonly used term 'case history'). Case studies are usually confined to small numbers of people or even individual 'cases' and usually depend on interview, observation and recorded self-description for their material. Surveys involve larger numbers of individuals and concentrate on gaining less information from each of them, but in a form that can be standardised to refer to the whole group – structured interviews and questionnaires are the preferred ways of doing this. Experiments aim at selecting a group of individuals to be representative of a much larger group (as large as may be necessary, in fact) and changing the things that happen to them in order to test a theory (or theories) held by the experimenter(s) that a particular kind of behaviour or experience corresponds to (or is caused by) a particular kind of change that they have been made to undergo. Thus by manipulating the experience of a few individuals in a small-scale, rigidly controlled environment, we may draw valid conclusions about what happens in certain kinds of situation within the world at large.

In the light of what I shall be saying about experimental approaches in the rest of this book, the above may seem to be a very simplified definition. It has been kept simple on purpose, however, so that it can be compared with the

other two models of investigation (survey and case study) in its basic identity as a way of dealing with the reality of human behaviour in the effort to understand it. Because experimental strategies have been refined and developed into standardised techniques, they are often considered to be intrinsically superior to simpler approaches, in the way that 'science' is better than 'mere guesswork'. This, however, is itself an unsophisticated attitude to take with regard to understanding and evaluating human behaviour.

These three strategies are not the only possible ways of enquiring into what goes on among human beings, nor are they mutually exclusive. Because the procedures associated with each of them are clearly distinguished, they provide useful starting points for research. Sometimes, however, it is possible to combine them in various ways – gathering a large amount of standardised information from a small number of cases, for example, or concluding an experiment using data collected from a survey. There is no reason why the same research questions should not be asked in more than one way so that the limitations inherent in one approach may be compensated for by the particular strengths of another – so that, for example, narrowness of definition may be balanced by width of description. Surveys may form a part of experimental design or a small-scale experiment included within a case study. Broadly speaking, each of the main research strategies tends to be associated with a different kind of intention: case studies with exploration, surveys with description and experiments with explanation. In fact, each may be used for any or all of these purposes.

On the other hand, the kinds of questions you intend to ask do suggest particular strategies. 'How' and 'why' type questions involve some attempt at creating circumstances in which the situation being investigated can be altered in some way and the difference between the old and new states of affairs compared – and this lends itself to an experimental approach, whereas questions about 'who' or 'what' (or 'where', 'how many', 'to what extent') do not immediately call for this kind of intervention and may be adequately answered by carrying out a survey. Case studies attempt to answer the same kinds of question as experiments, without asserting control over the situation being studied – so that if you wanted to find out how or why something happened without attempting to reproduce it under experimental con-ditions, you would concentrate on trying to understand it in as much depth as possible. Because you would not have to keep yourself aloof in order to preserve 'experimental objectivity', however, you could actually involve yourself in the situation you were studying and try to experience it at

first-hand using 'participant observation'. There is no fixed rule about this, however. Experiments, case studies, surveys may be used for all three purposes – explanation, exploration, description – or a mixture of all of them.

At the same time, each of the three main approaches has certain advantages and drawbacks. Experiments give clear information about causal inference but they have to be rigidly structured and will only yield information with regard to whatever it is in a particular state of affairs that the investigation has already decided is responsible for what is going on – choose the wrong factors in the situation to observe and measure and you misunderstand it altogether. The real world is not rigidly structured, a fact which weighs heavily in favour of the survey as a realistic research strategy. The problem here, however, is that surveys rely on people's responses to questions that have been devised in accordance with views of the world that are more or less personal to the questioners and are presented in ways that cannot always be depended on to allow the respondents the freedom they need to express themselves adequately. Precisely because they are open to the kind of interpersonal pressures imposed in real-world situations, surveys cannot be counted on to produce a completely accurate and authentic record of what people would really think and feel if left to themselves. Authentic information may, perhaps, be obtained by the kind of personal involvement on the part of researchers that is usually associated with case studies. Here, however, the degree of participation limits the number of examples that can be obtained, with obvious effects on the generalisability of results, and involvement of this personal kind is itself part of the interpersonal context that the researcher is trying to assess while leaving him or herself out of the picture.

Which is more important for the purposes of your research, being able to make a clear statement about causality or capturing an authentic record of real feelings and motives on the part of the people you are studying? Do you really need to know why certain things are happening or is it enough to find out how they usually happen? Can you rely on the people you are interested in to reveal the things you want to know in ways that they themselves will choose or do you consider it necessary to theorise in advance about the causes of their behaviour, feelings, attitudes, etc., and then contrive particular situations to find out if you have guessed correctly? These are the kinds of questions you must try to answer about your own intentions and assumptions before actually deciding how to frame the questions you want to ask about the situation you intend to investigate. If you cannot arrive at a clear answer, it

may well be wise to consider some kind of compromise approach involving elements of all these strategies – and ones you have devised for yourself – to fill the gaps in your design and make it really your own.

Method

The way you decide to carry out your research – the method you choose – depends on the kind of information you wish to gain from it. Ideally, the choice is made during the first stages of your enquiry because it is difficult to change things later on without going back to the beginning and starting again (difficult, but not always impossible!). If the original approach proves unsatisfactory on its own, however, it may be practicable to use alternative research approaches to supplement it. Logically speaking, recognition of the problem to be solved should precede any ideas we may have about how we are going to solve it. In fact, however, this is not always what actually happens. The situation which we are concerned to find ways of understanding cannot be changed – after all it is this particular problem that we want to solve. There are, however, several ways that we can try to understand it. If we are lucky, of course, we may find exactly the right kind of research technique that we need. If not, we must use the most appropriate one for our purposes. This may mean adjusting the situation in order to find a suitable way of testing it. This constitutes an ongoing problem, particularly with research methods which call for highly precise kinds of enquiry. If the technique is not so rigorous, however, there may be a chance that the situation will not require quite so much adjustment in order to make it fit. There is nearly always a degree of compromise involved here – the idea of asking questions before we can arrive at an appropriate answer to our problems is not as straightforward as we might have assumed.

If there is too considerable a gap between the particular problem to be solved and the available ways of solving it, there is no excuse, of course, for distorting the situation you are trying to understand. Consequently, researchers are always recommended to master as many methods of approach as possible. Some of the most useful ones with regard to investigating the arts therapies are described in the following chapters. Although the aim here is to concentrate on different kinds of experimental research, we should be careful not to ignore other approaches. Notable among these are questionnaires, structured interviews, personal diaries (particularly useful for gaining a greater understanding of the actual experience of therapy) and case studies (providing insight, realism and depth of understanding both on the part of

the individuals being studies and the researchers setting out to investigate them).

A Clinical Approach to Measuring the Effect of Music on Memory

Suin Cranny describes research carried out by a music therapist in a school for children with specific learning difficulties. The work investigated a specific use of music by teachers in the 'special education' setting and examined the traditional belief that combining information with melody will help children learn in specific tasks. It is included here as an example of a straightforward attempt to measure something that is measurable.

A series of experiments was reported in which the effect of melody in a learning task is examined. The first examined the learning of a poem with and without melodic stimuli. The second contrasted the short-term retention of melody and digits as verbal units in the same group of children. The third test examined the effect of using learnt and unlearnt melody as the learning aid and the fourth was a small 'follow-up' study to compare the effect of learnt melody, unlearnt melody and no melody at all. Results showed that melody can work as a learning aid but that the type of melody, that is learnt/unlearnt, is a critical factor.

The study was an investigation of a traditional belief. The result of the pilot study disconfirmed the original hypothesis that melody would act as a learning aid. The remaining investigations were examinations of that finding. (Included in Kersner 1990, p.98)

To return to our outline of the decision involved in setting up research. Up to now, you have decided what you want to look at more closely, settled on the actual questions you will need to ask in order to get the information you are looking for, arrived at an idea as to the strategic approach you will use for your research and considered ways of putting it into practice. That is, you would have done these things, arrived at this stage, if nothing else had got in the way.

In fact, many things can and frequently do prevent the research process from flowing as easily as this suggests. Even researchers with years of experience make false starts, discover circumstances they had overlooked and have to refocus, even admit the part played in their research by sheer luck or other kinds of circumstances for which they can find no good scientific explanation. The logic of the research approach is something that researchers aim for, not a position they are able to start from – or, rather, it is a theoretical

model which, if firmly grasped and properly internalised, may eventually achieve realisation in a form which is acceptable to other researchers. The stages in the research process that I have been describing represent the logical development of the idea of research and this needs to be put into practice as faithfully as possible, bearing in mind the fact that even experienced researchers may, and do, make mistakes. What is advocated here is respect for the research process and the method of scientific inference on which it is founded. This in itself involves a definite attempt to move forward towards a recognisable conclusion, being as systematic as you can be in the process (see Martin 1981 for the dangers of indulging in 'garbage can' research).

Certain basic considerations of order are fundamental to any serious research project. First of these is the need to gain people's permission to carry out your investigation on their premises – whatever this word may entail in any particular circumstances. Generally speaking, a strictly organised research project will meet with less opposition than one where too many details have been left to chance. Obviously, you are going to be given a freer hand by the people who have actually invited you in than by those who have not. But even when the research has been specially commissioned you may want to widen your scope of enquiry to include people you were not originally expected to ask. There is a difference between what you are actually empowered to do by those in charge of the area you intend to work in and what you may actually be allowed to carry out by the people you will be working with. In some cases official permission will not carry as much weight as openness and charm do, when combined with belief in the importance of the research you have undertaken – with their help – to try and carry out. Let people know how long your research will take – this applies to the people actually taking part in your research as well as the authorities concerned. Sometimes, it may be wisest, of course, to obtain an individual's (or institution's) written consent. Sometimes, you may find yourself researching for the institution you yourself are employed by, in which case you would be advised to carry out a little preliminary investigation of your own in the attempt to find something out about the possible reception of differential outcomes of your study! The roles of colleague and researcher are hard to combine and present difficulties in hierarchically organised settings or where you yourself are privy to confidential information concerning the people you are interviewing. And what about your day-to-day relationships with the people you are used to working alongside? If you find yourself

combining roles like this, you are advised to find ways of undergirding your researcher role – perhaps by forming alliances with independent researchers outside the organisation (Grady and Wallston 1988).

Second, pilot runs are useful in data collection and definitely necessary for experiments where it is always useful to have some kind of 'trial balloon' for the main project. Case studies can actually include this kind of introductory work within the final account.

Third, remember to pay attention to the way in which you intend to time the various sessions involved, whether these consist of observation, interviewing or actual therapy. It need not be a very sophisticated schedule but if you are going to see your project through to a satisfactory conclusion, you will certainly need it.

Fourth, try to prepare yourself for a research project which is unlikely to be easy, even though you may think you have prepared for everything that can possibly happen to prevent it from being completely successful. However well you manage things, you are dealing with human beings, who can become ill, and human arrangements, which can go amiss (and, at some point, almost certainly will). At all stages of the research, if it is possible to have contingency plans and alternative resources, try to provide these. If your original plans turn out to be overambitious, see if you can cut them down to size without changing them in fundamental ways. Always try to be flexible. Try, if at all possible, to build your growing understanding of your material into your research as it develops rather than scrapping all you have done and starting over again.

Data Collection

This is the heart of your actual investigation, the point at which you put into practice the thinking and planning which went into your research strategy. As we have seen, there are several ways of collecting data – some of the more straightforward ones will be mentioned in more detail later. Obviously, the way you choose your material – what you record as evidence of the logical value of your argument – must reflect the kind of things you want to find out. In other words, the best data-collecting method you personally can employ will be the one that gives you the most help in answering the research questions you have chosen to ask. Things like resources, time available, expertise (or lack of it) and, of course, your sponsor's attitudes and expectations must be taken into consideration as well, but the fit between enquiry and collection must be as close as you can make it. Using more than

one data collection method may give you the flexibility you need by allowing you to balance the strengths and weaknesses of each – often a way of organising your material which is easier to handle in research that does not involve rigorous statistical procedures.

When it comes to it, there are several important personal factors to be considered. You have to find ways of collecting data that you yourself, with your skills and personality, can actually manage to put into practice. You have to take the ethical implications of what you want to do very seriously – to what extent are you willing, for instance, to intrude upon other people's privacy? To ask questions they may possibly find offensive? To watch them doing things when they don't know anybody's looking? (One advantage of carrying out pilot studies is that they bring these questions out into the open before the main investigation begins.) In any kind of study your main research instrument is yourself. The integrity of your research depends on your own integrity. It is your personal investment, your ability to care for what you are doing, that will involve other people, convincing them that all this effort is worthwhile and that co-operating with you is actually going to advance the cause of human understanding. First of all, though, you must convince yourself – otherwise you are unlikely to reach the end of the task you have set yourself.

Analysis

Quantitative analysis uses numbers to draw its conclusions and qualitative analysis uses words. Sometimes, research projects adopt a hybrid design, using elements of both these models in order to be as comprehensive as possible or because measurement does not provide all the information required and descriptive material is needed as well. Because qualitative research is more concerned with describing processes than demonstrating results, these hybrid designs tend to be more qualitative than quantitative, numbers being used to quantify ideas or impressions and render them more systematic.

Data itself may be of many different kinds – test results, questionnaire answers, protocols, tapes (both video and audio), metered responses; diary entries, reports of meetings, documents, written reactions produced during a test session; monitored gestures, significant use of body language, movement, space; projected symbols of various kinds, etc. All these things may be turned into either numbers or words, or words that can be associated with some kind of numerical system. Quantitative (number-based) analysis

uses statistical methods to assess probability – that is, to measure the chances that such and such a thing is going on or that this effect is produced by these causal factors within the situation being investigated. A great number of statistical procedures are available to assist in this procedure. Some of these are beyond most people's mathematical range and should be left to experts. In fact, as a general rule it is advisable to seek skilled advice, unless, of course, you happen to be an expert yourself. Otherwise, the temptation is to learn some of the more accessible statistical tests and confine yourself to these, when a more sophisticated test, lying outside your present range, would produce more meaningful results. This does not mean that you should set about becoming a statistical expert or that you should avoid learning anything at all about the use of statistics in behavioural testing. It is simply a warning against indulging in extended statistical analysis for its own sake on the one hand or, on the other, refusing to have anything at all to do with the scientific aspects of your own work. Simply having the recommended computer package is not enough. Just as you need to understand the principles of scientific investigation if you are to carry out a convincing research project, so you also need to have a working idea of how statistical analysis functions and not simply opt out of that aspect of things altogether. As we shall see later on, even research that is qualitatively conceived needs to pay attention to the rules of scientific inference and this means getting to know the same basic principles that underlie statistical procedures. Advice about statistical analysis needs to be taken when you first begin to design your project, not after you have finished collecting your data. A little learning is only dangerous when it is carried out in isolation (like secret drinking!) (Robson 1993).

Qualitative research does not draw on statistical methods of verification and validation to the extent that quantitative research does. It, too, is systematic, however. Because it indicates such a wide field of enquiry within a single project, it involves a great deal of organisation and the ability to orchestrate its effects so as to present its conclusions as powerfully and convincingly as possible. Even though it is concerned with quality rather than quantity, it is still a form of research and must, therefore, pay attention to the way in which it argues. When it comes down to it, all research concerns itself with likelihood rather than actual proof. Qualitative research must demonstrate that what it produces is as authentic a presentation of reality as can be achieved using the methods it has employed – in other words, as likely to be true.

Reporting

Communicating what you have discovered from your research is an integral part of the project and you must find an appropriate way to do this if your investigation is to be taken seriously by others interested in your subject. You can easily find out how research projects are presented to the academically oriented public by consulting examples which have appeared in scientific and professional journals. Some of these are more formal and technical than others, however, and it may well be that the kind of project you have been involved in calls for a more relaxed approach. If your research is qualitative, its identity and purpose may well be misrepresented by a report that is too academic. On the other hand, you will certainly need to produce some kind of review of the processes involved in your enquiry and the meaning you attach to its findings. If you want your work to reach a wide audience, you will need to find more than one way of getting it across. Videos, magazine articles, talks and seminars – even radio and TV 'slots' – are all ways of widening the scope of your basic experimental report. Try to give as much attention to the business of communicating the results of your project as you did to carrying it out.

This is particularly important, of course, if you intend some kind of action to be taken as a result of your findings. Discussions about this should not have been left to this late stage, however. If you are planning to carry out a research project with a view to intervening in a particular area in accordance with evidence provided by the project, you need to be aware of this fact from an early stage in the research, if not from the very outset. For example, if you are contemplating the kind of investigation that is likely to have an effect on the lifestyle or work conditions of the people involved as subjects of your research, you may want to include them in your plans from the outset. In this way you can avoid any suggestion of 'taking them for a ride' while being in the best position to gauge their reactions to the research and gain as much, and as accurate, information as possible. If you are working to bring about changes in people's lives, you will certainly need as much insight into their personal experience as possible – even then, there is a limit to the kinds of things anyone can do by means of experiments, however skilfully carried out.

Quantitative and Qualitative Research

There are two principal approaches to investigations intended to constitute research into any area of theory and practice. The first is quantitative, the second qualitative. Quantitative research is concerned with measuring change in things and/or people in a way that establishes a high degree of probability that the degree of change occurring in a small number of instances ('experimental subjects') would actually occur everywhere that the same situation was reproduced ('experimental conditions') and the same kinds of people or things were involved. It uses statistical techniques to assess probabilities and, consequently, is able to measure differences in a strictly mathematical way in order to test the idea ('hypothesis') that it is this particular combination of circumstances ('experimental variables') that has caused the change to take place. In authentic scientific tradition tests are carried out under rigorously controlled circumstances in order to decide whether this change or changes ('experimental effect') are actually the result of mere chance; the validity of the hypothesis is asserted to the precise degree that this kind of error has been demonstrated to be unlikely (Robson 1973).

Qualitative research aims at enabling us to look closely at sets of circumstances that would be difficult, or even impossible, to measure in this way – for example, things concerned with the quality of human relationships and what happens between and among people. It concerns itself primarily with investigating how things happen rather than trying to be scientifically accurate about why they do. Certainly, this involves paying attention to questions about the extent to which changes occur but it is recognised that precision in this area is not always the most important factor and that the urge to isolate firm causal connections may, and often does, end in a way of regarding process that discounts genuine involvement in whatever it may be that is really happening. The danger of isolating the wrong causal factor is avoided by trying to cover as many aspects of whatever is being investigated as possible, not in order to guard against the possibility of there being other ways of explaining the situation but in order to unearth as much evidence as possible that the investigators' understanding of what is taking place is a valid one.

Measurement in qualitative research tends to refer to the order of importance in which individuals have ranked their own or other people's experiences or reactions in the area being researched – for example, '1, 2, 3' will refer to 'first, second, third in order of importance or occurrence', it does not signify that 2 is twice as important or occurs twice as many times as 1 and

3 adds precisely a third more of whatever is being measured. Evaluative research depends on subjective judgement. This is considered to be necessary because of the kinds of subject matter it deals with. It certainly does not mean that this approach is less systematic. It may be less scientifically reliable but it has a better chance of being relevant to the material it concentrates on (King, Keohane and Verba 1994; Maxwell 1996).

Reading List

Everitt, B.S. and Hay, D.F. (1992) *Talking about Statistics – A Psychological Guide to Data Analysis.* Chichester: Wiley.

Mann, P.S. (1998) *Introducing Statistics.* Chichester: Wiley.

The Quantitative Approach

In this chapter I shall be looking at the way in which human behaviour can be explained in terms of statistical probability. As I am a dramatherapist and not a scientist, this will necessarily involve a certain degree of over-simplification.

The Research Paradigm

This is concerned with measuring changes in behaviour in a way that establishes a high degree of probability that the degree of change which occurs within a small sample of people under certain conditions would occur everywhere that these conditions were reproduced and the same kinds of people were involved. If the people used as experimental subjects are selected at random, it is assumed that results extrapolated from measuring changes in their behaviour are characteristic of people in general – 'If *this* happens to you, you are highly likely to react like *that*.'

Only likely, however, because statistical methods measure probabilities. They do not establish something as certain. They are mathematical inferences, not really proofs. What they seem to do is to go as far as they can to demonstrate that the change they are concerned with has not simply occurred by chance. It is *these* causes which are responsible for *these* effects and there is only the slightest probability that the reasons for change lie elsewhere.

If, in fact, they do, there is no difference between people who have been subjected to the particular circumstances that are under consideration – the circumstances which are hypothesised as causing the changes – and people who have not. In other words, along with the hypothesis that these circumstances are responsible for the effects that are being observed and measured, there must always be another hypothesis which considers the possibility that they are not. This is known as the null hypothesis and it is this one that is subject to statistical testing (in accordance with scientific

procedure, which always tries to prove theories wrong in order to establish their rightness!). The null hypothesis is proved false (or demonstrated to be extremely likely to be false) by establishing that the changes that have been observed would not have happened if it were true. If the null hypothesis were true, there would be a high probability of chance involved in the fact that these changes had occurred.

Statistical tests are applied to the data in order to establish whether or not the null hypothesis is true. If there is a very low degree of probability that it is true, there must be a high probability that it is false – in other words, that the *original* (what is called 'experimental') hypothesis is the true one. The lower the probability score, the more convincing the evidence that the changes were in some way dependent on the observed circumstances.

Statisticians talk about experimental results in terms of the presence or absence of 'statistical significance': 'There is a convention whereby a significant level of probability, $p = 0.05$ (the 5 per cent significance level) is referred to as *significant* and the significance level of probability, $p = 0.01$ (the 1 per cent significance level) is referred to as *highly significant*' (Robson 1973, p.35). By their lowness, these levels demonstrate a high probability that the changes observed were the result of the factors asserted by the experimental hypothesis – in other words, that the experiment has been successful.

Whatever may be thought of this approach as a way of drawing conclusions about the causes and effects of human behaviour, it should be pointed out that those who work in this way are usually conscious of the scientific problems involved, even if, as we shall see later, they sometimes show little concern for the human ones. As scientists, they would prefer to be more exact than the statistical approach allows and to deal with certainties (as they construe them) rather than probabilities, however high. It is because it is impossible to observe everybody and measure every instance of the behaviour in question that they are obliged to make mathematical inferences from the relatively small samples of behaviour available to them.

Figure 4.1 shows the steps involved in designing quantitative research projects. As I have already said, these are more suitable for arriving at conclusions about the outcome of processes (and consequently their inputs) than trying to understand what is actually happening in the processes themselves.

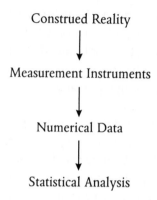

Figure 4.1 The Principal Stages of Quantitative Research

Construed Reality

Because quantitative research is about testing propositions, you must have a definite idea from the beginning of the testing procedure precisely what it is you want to establish. This means that a good deal of concentration goes into producing the kind of proposal that can be statistically tested. By concentration I mean hard mental effort aimed at clarity and simplicity – all your thinking on a particular subject must somehow be brought to bear upon the necessity of formulating a single question, the answer to which will somehow illuminate the entire picture. This action of focusing on a particular idea is fundamental to quantitative research, which is always a narrowing down in order to isolate a factor, or combination of factors held to be of crucial importance. If you already know what it is you want to test, this task is reasonably straightforward.

For example, in the experiment mentioned in Chapter 2, the intention was to find out whether or not experience of dramatherapy would reduce thought disorder. All the same, a good deal of thinking provided the background and basis for this, and many questions had to be tackled before the experimental proposal emerged in its final form. For instance, my fellow researcher and I were fascinated by the kinds of change we had noted in the day hospital patients involved in our dramatherapy sessions, but what kind of change was it? How were they different? The answer required research into what had already been written about dramatherapy, discussions with other dramatherapists, the careful choice of material for actual dramatherapy sessions, etc. Thought disorder did not emerge as a phenomenon which

might be relevant in this context until quite late on, after we had considered many aspects of behaviour, some of which were measurable and some not. The idea first arose as a result of our forming theories about the relationship between styles of communication and mental illness based, in turn, on the work of Bateson and, later, of Bannister.

Our theory was that social contexts specifically designed to promote a sense of personal identity would lessen the kind of boundary confusion with regard to persons and things designated as schizoid thought disorder, and that dramatherapy provided such a context. This was our 'construed reality', the position from which our investigation would begin. We also had another agenda, however, represented by a determination to see whether or not dramatherapy actually 'worked'. This second purpose was not completely divorced from the first one: if we could show that it reduced the degree of thought disorder, we would both demonstrate its ability to bring about therapeutic change and also provide important evidence about the causes of the condition we were trying to alleviate. The need to be definite dictated our choice of a quantitative research strategy.

This meant that we had to express our theory in straightforward terms of 'before' and 'after'. If people whose thinking was disordered took part in a course of dramatherapy, their thinking would become less disordered. Quantitative research depends on 'operational definitions' of the theories it sets out to test, cutting them down to size. The richness of the original idea is sacrificed to the clarity and definition of the final result. *This* definitely had a significant effect on *that*. In scientific terms, this *caused* that (see Figure 4.2).

Measurement Instruments

In the first part of the experiment, reality, as it concerns the quantitative paradigm, is first construed – that is, understood – and then defined, reduced to manageable proportions and rendered 'experimenter-friendly'. This process is continued in the second group of operations, those concerned with choosing the kinds of instruments which will be used to carry out the experiment. This is usually called the 'experimental design'.

There are many kinds of experimental design and it is the task of the investigator to choose one that is appropriate for the experiment he or she intends to carry out. There are different kinds of result, different kinds of experimental subject, different timescales, different ways of deciding what constitutes the success or failure of an experiment, different ways of measuring the phenomena in question. 'In an experiment, one investigates

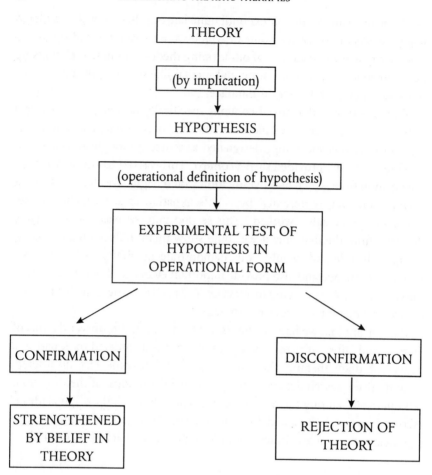

*Figure 4.2 The 'scientific paradigm' on which quantitative research procedures
are based. (Adapted from C.L. Sheridan,* Methods in Experimental
Psychology *(1973) New York: Holt Rinehart and Winston)*

the relationship between two things by deliberately producing a change in
one of them and looking at, observing the change in the other.' (Robson
1973, p.15). Within the experimental paradigm, the thing which we
deliberately change is known as the 'independent variable'. By
'independent' we mean that we shall try to keep this away from any
influences which would produce a change in it. It certainly isn't independent
of it because we are able to increase or decrease the amount of it we will bring

to bear on the thing we are examining – the 'dependent variable' – which changes to an extent 'dependent upon' the degree to which it is brought into contact with the independent one (or ones – there may be several independent variables but only one dependent one).

Our experimental design represents the way we bring these two kinds of variable together in order to measure the effect of the independent variable(s) upon the dependent one. Under what 'experimental conditions' are we going to subject the former to the latter? If our main concern is to establish whether or not the independent variable has any effect at all on the dependent one, we will limit ourselves to two conditions: the *presence* of the independent variable and its *absence*. These are called the 'experimental condition' and the 'control condition'. The experiment will concern the difference between the results obtained in the first condition (experimental) and those given the second (control).

Numerical Data

A decision will have to be made about the scope of the experiment. This concerns the kind of data we want it to produce. We want to draw conclusions about the entire class of things to which our dependent variable belongs – even though we can only actually observe what happens with a relatively small number of examples. In statistical jargon, in order to find out about a 'population' we concentrate on a 'sample' and use a statistical procedure to draw conclusions about the greater number from the smaller one.

There are two kinds of test we can use to find out whether or not the independent variable has had an effect on the dependent one: 'parametric' tests and 'non-parametric' ones. If a test is parametric, its action is to extrapolate statistically from the results obtained within the sample to the entire population, so that the conclusions it draws refer to every instance of what is being studied. Non-parametric tests, on the other hand, concentrate on the state of affairs revealed within the sample itself, first making sure that its subjects have been carefully selected beforehand to be as representative of the wider population as possible. Subjects studied at the same time and in the same place may well share characteristics which are not representative of the wider population to be studied and so selection involves allocating them randomly between the two experimental conditions to prevent 'bunching'. This kind of procedure is used for both kinds of test. However, the presence in a sample of markedly non-typical individuals will affect the results of a

non-parametric test more than it would a parametric one (because the former limits its conclusions to the sample while the latter measures probability within the entire population).

Non-parametric procedures draw their conclusions from the order in which things have been arranged. They are often known as 'order techniques'. Consequently, they are frequently used to test experiments in which judges have ranked the behaviour they were observing and then given each particular position a numerical value. This is a way in which unmeasurable things such as attitudes and degrees of emotion may be translated into the language of science by attaching numerical values to personal judgements. Such 'ordinal' scales should not, however, be confused with the 'interval' scales in which successive ranks are separated from each other by the same degree of distance throughout. These are the scales we use to measure with precision. In order to use one of these for measuring human experience you must somehow give judgement a kind of mathematical precision it cannot aspire to! For this reason, non-parametric testing based on ordinal ranking can never be as mathematically sound as parametric testing. We should remember this when we talk about 'behavioural science'. The part played by intuition and ordinary human (which means biased) judgement in this kind of psychological testing should never be overlooked.

Statistical Analysis

This can only take place, of course, when the experiment has given rise to data which can be analysed. The three components – measurement instruments, numerical data and statistical analysis – all hang together and are mutually dependent, so we have to have an overview of the investigation before we begin. We choose our design with a view both to the kind of data it will produce and also to the way in which we can analyse our data. Different designs correspond to different analytical approaches. For example, there are several ways, both parametric and non-parametric, of analysing data with a view to measuring the degree to which one thing affects another, and others for assessing the extent to which one thing reacts in relation to something else (correlation) or several different things interact with one another (analysis of variance). Particular tasks correspond to different kinds of data, so that if a decision is made to change one test to another it will involve redesigning the entire experiment in order to produce the right kind of results – that is, results presented in the right way for this particular statistical procedure. Thus it is always a temptation to begin by choosing a statistically

dependable ('robust') test and then to go on and design a suitable experiment to fit this. There is nothing wrong with doing this, of course, if your main purpose is to produce the kind of results you can draw firm conclusions from in the discussion section of your research paper. In the eyes of most of the people who read them, research papers are judged by the clarity and definition of the results and the scientific status of the procedures used to measure them. A truly scientific appraisal is more concerned with these things than with whether or not your argument has been proved true or false.

You, however, are expected to be primarily interested in whether or not your experimental hypothesis has been vindicated by the results. The trouble with designing experiments backwards is that it puts dangerous constraints on your choice of what it is you actually want to investigate. There is a tendency for really interesting questions about human behaviour to be hard to answer in ways that are easy to measure. Influenced by the desire to produce the right kinds of answer, you run the risk of changing your question. Statistics prefer straightforward choices. In human experience such decisions frequently miss the point.

Quantitative experimental investigations reach what are conventionally regarded as firm conclusions – in other words, they hold to the criteria for trustworthiness recognised by scientifically minded people. If you were to repeat the experiment exactly as it had been carried out in the first place – better still, if somebody else were to repeat it by going through all the stages you went through, using the same kinds of people as subjects, exercising the same controls, keeping to the same timescale – the same kind of data would reveal the same kind of results. It might not be the kind of result which would tell you very much about the reality you were interested in but it would be scientifically respectable and, in some circles, that is all that matters.

A Quantitative Investigation: The Use of Dramatherapy in the Treatment of Thought Disorder (Grainger 1987)

A grid test was used to measure thought disorder in an unselected group of patients at a psychiatric day hospital, before and after taking part in a course of ten one-hour sessions of dramatherapy. Comparison of the results showed a significant treatment effect in the direction of thinking that was more ordered on the part of those subjects whose construing had previously been least intense and consistent.

Introduction

Accounts of the therapeutic effects of dramatherapy tend to be somewhat vague, often couched in psychoanalytic language about the achievement of catharsis and the reintroduction of repressed material to consciousness, effects which are notoriously difficult to isolate. The use of drama to increase people's ability to give cognitive structure to their perception of other people suggests the employment of techniques which produce results which may be more readily evaluated. Such an approach would help clarify these aspects of the 'private' language of schizoid thinking that call forth a response from other people and result in genuine communication. Whether schizoid thinking is characterised as excessively narrow, limited and concrete (undifferentiated, primary process thinking) or too broad, generalised and over-inclusive (Bannister 1962; Johnson 1981; Lidz 1968, 1975), there seems to be general agreement that thought-disordered people have difficulties in discriminating between subject and object, self-as-participant and self-as-observer, and in categorising different degrees of involvement and concern. According to Bannister (1975) what is needed is an opportunity for human experiences of an unambiguous kind, structures simple enough for the thought disordered to use as matrices for encounter without engulfment, and flexible enough to allow a degree of experimentation with the intra- and inter-psychic communication of thoughts and feelings: 'Future work ... might well start from the premise that patients must be allowed to create their own worlds in which they can explore relationship with each other and the therapist' (p.179).

Studies of dramatherapy have frequently limited themselves to setting forth an underlying theory without attempting in a systematic way to evaluate results of treatment (see Emunah 1983; Johnson 1982; Landy 1982; Mazer 1982; Rayner 1984). Irwin, Levy and Shapiro (1972), on the other hand, used a projective test, the Rorschach Index of Repressive Style, to evaluate the effect of dramatherapy on latency-aged boys suffering from emotional repression and lack of verbal fluency with significantly successful results. The present investigation also uses a psychological test, the Bannister and Fransella (1966) Grid Test of Schizophrenic Thought Disorder. It involves a cross-section of patients attending a psychiatric day hospital who took part in a ten-session programme of dramatherapy with a view to measuring the effect of this experience on their ability to order their thoughts in a more consistent and effective way than they did before. The

programme was not specifically designed to measure thought disorder but included some people designated thought disordered by the grid test.[1]

Method

SUBJECTS

There were 24 subjects (17 female and 7 male) ranging between 38 and 75. Each had attained a score of more than 8 on the vocabulary sub-scale of the Wechsler Adult Intelligence Scale. Selection was by successive referral, patients being automatically assigned to one or other of two groups in the order that they arrived at the day hospital. There was no attempt to select patients diagnosed as suffering from thought disorder and the policy throughout was to try to avoid presenting the programme as any kind of experiment – it was simply 'part of the treatment'.

DESIGN

A 'crossover' design was adopted. During the first 10 weeks Group A received treatment but not Group B; during the second 10 weeks Group B but not Group A. All 24 subjects were tested (using the Bannister and Fransella test) three times during the course of the experiment – to begin with and before and after Group B's sessions. In this way everyone received the benefit of the treatment and delayed or transitory effects could be noted.

PROCEDURE

Before proceeding with the main part of the investigation, a pilot study was carried out in order to locate possible procedural problems, both in the testing and in the sessions themselves. This involved seven subjects, 2 men and 5 women, taken at random from those who were already patients at the day hospital. The results were encouraging enough for us to proceed with the main study.

In this, two groups of 12 Ss (Groups A and B) received a course of dramatherapy consisting of ten one-hour sessions taking place once a week. The sessions involved various aspects of interpersonal activity, starting with simple exercises in awareness of other people and becoming progressively more complex and demanding greater cognitive flexibility (i.e. increased perceptual reflexivity) and a greater ability to predict other people's

[1] This investigation is described in more detail in Milne (1987).

behaviour and share their feelings. A change in the direction of increased intensity and consistency of construing was predicted as measured by the thought disorder test. In this, two scores are obtained, which, taken in conjunction with each other, produce a thought disorder score. This is expressed in terms of the percentages of subjects achieving a lower score – that is, those scoring higher than the cut-off point are not considered to be thought disordered. The procedure for administering this was as follows:

> Place in front of the S an array of 8 photographs, 4 male and 4 female. Ask the S to study these, saying: 'I'm going to ask you some questions about the way you think these people look to you.' Ask the S which of these people is likely to be KIND. When the S has made a choice, write the letter pointed to on the back of this photograph on the score sheet under the heading KIND. Go on to ask the S to choose the kindest looking person from the remaining 7 photographs and note the letter on the back in the KIND rank under the first choice. Continue doing this until the S has ranked all 8 photographs, from kindest to least kind. Shuffle all the photographs and start again. When the S has ranked all the photographs with regard to all the categories – KIND, STUPID, SELFISH, SINCERE, MEAN, HONEST – ask him/her to repeat the whole procedure. ('Change your mind if you want to, this isn't a memory test').

There are now two sets of ranked letters, forming two grids – one for each of the two complete trials carried out by the S (Figure 4.3).

The subject is asked to carry out the procedure twice in order to gauge the degree of consistency between the two versions. This is one of the two dimensions contributing to the final thought disorder score. The other dimension refers to the degree of conformity among ranks within each grid. How similar is one ranking ('honesty', say) to another ('kindness', for example)? Are there any pairs or groups of ranks which resemble each other? Are there any striking reversals of order? Are the ranks all very different from one another? This is the dimension of intensity because it refers to the closeness of association between categories in the construct system or way of making sense of the world.

Results

Figure 4.4 shows the difference between mean scores for experimental and control conditions.

Grid 1							Grid 2						
	K	St	Se	Si	M	H		K	St	Se	Si	M	H
1	C (3)	H					1						
2	B (2)	B					2						
3	H (8)	D					3						
4	A (1)	F etc.					4						
5	D (4)	E					5						
6	E (5)	C					6						
7	G (7)	B					7						
8	F (6)	G					8						

Figure 4.3 Grids of rank orders (numerical values in brackets).

These results were divided into a higher and lower scoring group, the latter consisting of those subjects shown by the Bannister and Fransella test to be below the thought disorder cut-off point before the experiment began. For this lower scoring group there was a significant (5% level) improvement in both consistency and intensity. Because one group's control condition took place before the dramatherapy sessions and the other's after them, the simple comparison of combined experimental conditions is somewhat misleading. In Figure 4.5 the mean pre- and post-intervention scores of the lower scoring group are compared separately.

	Intensity		Consistency	
	Exp.	Cont.	Exp.	Cont.
Group A	3.54	- 0.38	0.03	0.1
Group B	1.50	2.34	0.03	0.1

Figure 4.4 Comparison of mean score

Intensity		Consistency	
Before	**After**	**Before**	**After**
6.87 (A)	9.83 (B)	0.40 (A)	0.73 (B)
7.14 (B)	10.94 (A)	0.55 (B)	0.64 (A)

Key:
A = experimental order → control order
B = control order → experimental order
Figure 4.5

In fact, the detailed results showed a slight fall-off for Group A during the control condition (which, in this case, followed the experimental condition) and a distinct trend in Group A's results towards improvement during the pre-intervention control period. From Figure 4.5 it can be seen that for both intensity and consistency each group's experimental scores are higher than the pretreatment scores of either group. Of the seven people who scored less than 10 (grid test cut-off score) for intensity at the beginning of the investigation, all seven showed improved scores at the end, three having lifted well clear of the thought-disordered criterion by the third and final testing. (Of the eight scoring less than 10 at the beginning of the actual drama sessions for their group, as distinct from the beginning of the experiment itself, seven had increased their scores by the end of the experiment, the eighth showing less of an increase than during the control period for her group while still scoring higher than she had done to begin with.)

Discussion

This test records the degree of associative activity ('intensity' and 'consistency') in a S's own judgements. It does not make its own judgements or represent the judgements of the experimenters, it simply measures the finite number of associations that take place out of a finite number that could do so. In other words, this was a genuinely quantitative experiment.

As predicted, a degree of improvement was recorded in the thought-disordered patients' construing of other people after dramatherapy. However, the improvement in Group B's performance during the

pretreatment period seems to indicate that day hospital attendance may have contributed to this finding. Dramatherapy may enhance the benefits of attendance, although a genuinely 'untreated' control group would be needed to give this interpretation substance. The results of Group B reveal the sudden invalidation of one person's construct system within the course of a single test period associated with the onset of clinical depression (Bannister 1960). Although this only occurred in one out of a group of twelve subjects, the statistical effect was dramatic.

This in itself points to an important weakness in the study. Where so few people are involved, the presence of markedly abnormal data affects the generalisability of the whole sample, making it impossible to use it as evidence of the way the parent population (in this case, all day hospital patients) would react to dramatherapy. It would have been much better to have used a non-parametric test than a parametric one. The T-test[2] was chosen because it has been proved to be a useful way of drawing statistical conclusions about the behaviour of large numbers of people from the evidence provided by groups which may be considered to be genuinely representative. We would have done better to use, for example, the Wilcoxon test, which is described as suitable for repeated measures (or 'before and after') designs 'where the data is obviously non-normal' (Robson 1973). Unfortunately, we decided on the T-test before we examined our data properly.

The experiment illustrates how difficult it is trying to be 'experimentally rigorous' in a situation in which rigour of any kind is obviously counter-productive. In this case, rigorous testing meant the creation of a structure designed to keep treatment modality, as distinct from the testing procedures, more or less as watertight as possible. Dramatherapy lays stress on spontaneity and freedom of action and reaction. There was no (obvious) selection process and no compulsion to take part. Consequently, the need to undergo the thought disorder test created a particularly clinical impression and some of the subjects needed persuading to take part in this. There was some attempt on the part of the testers to circumvent the problem by designing tests which would 'double' with dramatherapy processes. For example, an informal 'repertory grid' was carefully built into the action

2 T-tests are used to establish the statistical significance of differences between mathematical means (The t-statistic is 'a difference in means measured on units of standard error'. Robson 1973, p.71)

during the first and last sessions of each treatment programme. Group A refused to allow themselves to be scored and Group B only participated unwillingly (producing a group intensity score of 178 at the last sessions, compared with 162 for the first). In retrospect it was clear that this kind of ambiguity would be resisted. Dramatherapy aims at frame clarity; people allow themselves to become involved in it because they 'know where they are' with it. There is an important difference between a metaphor whose implied meanings are shared by the group and a hidden agenda built into the proceedings by those in charge. Blurred outlines were precisely the difficulty that was disabling our clients! In practical terms this meant that the integrity of the course of sessions had to be preserved against the introduction of material which represented the kind of stereotyped client-professional, doctor–patient relationship which structured the world of outside therapeutic space. This is not to say that dramatherapy and psychological testing may not be used with the same clients but simply that they should not be used at the same time and in the same way, as if they were the same kind of thing. In fact, it is worth pointing out that if a quantitative approach were considered to be necessary, as it was in this case, the thought disorder test was particularly appropriate, dealing explicitly as it does with the way people construe one another, according to physical appearance at least, and the task of judging the significance of people's facial expressions would seem to lead easily enough into the kinds of interpersonal process explored in dramatherapy. In this case, perhaps, the testing procedures could be seen to be thematically related to the treatment modality.

Results showed that the clients who had suffered from a recognisable degree of thought disorder before the dramatherapy sessions had ceased to do so afterwards. Because of the small sample size and the presence of uncontrolled variables (factors not taken account of or impossible to measure), such as the effect of day hospital attendance and symptom-controlling medication, it was not possible to make valid statistical judgements about all people who suffer from thought disorder. It would be valuable to carry out a similar experiment using a larger sample or, if this were not possible, a more suitable statistical test. However, the evidence presented here does seem to suggest quite strongly that the ability to think clearly and practically is not lessened in any way by experience of dramatherapy (and probably of drama itself – cf. Duggan and Grainger 1997). Certainly, in terms of interpersonal behaviour and individual experience, all the people in this investigation who appeared to be construing most loosely to begin with

were, by the end of the course of sessions, participating more enthusiastically and creatively in the life of the group. This was not measured by the grid test, of course, which restricted itself to recording an increase in intensity and consistency of construing. It is a conclusion drawn from what the group facilitators saw of the behaviour and attitudes of the people concerned and what those people themselves said about the change they had experienced in the way they thought and felt about life in general, before and after their involvement in dramatherapy (Grainger 1990).

The increase in the consistency score was notably less than that for intensity. In fact, Group B (experiment ⟶ control) scored higher after the control period than the experimental one. From the point of view of our theory about the effects of dramatherapy, this was not what had been predicted. On the other hand, it fits in with other observations about the behaviour of people involved in activities of an artistic kind. Artistic expression has usually been associated with spontaneity and unpredictability. In a situation in which people are consistently urged to be inventive and find new ways of putting things, ideas and situations together, more attention will be paid to making associations (intensity) than retaining them (consistency). Eisner (1985) points out that exploratory mental activity improves people's ability to organise instrumental as well as expressive behaviour. It would seem in our case that this kind of activity may have made our subjects more skilful in reorganising their constructs.

The study also showed a good deal of variation with regard to the degree of intensity of subjects' construing (intensity scores ranged from 2.83 to 21.41). Only subjects with scores above the cut-off mark (i.e. subjects whom the test did not regard as having a significant degree of thought disorder) scored lower after treatment than they had done before taking part. Everybody who had been categorised as thought disordered retested as normal. Taken all in all, the investigators considered that the experiment showed dramatherapy to be an effective way of treating thought disorder because of the degree to which the personal construct systems of thought-disordered people had been tightened by taking part in it.

An interesting footnote concerns the case of one subject taking part whose construct system was very tightly organised to begin with and showed considerable loosening after the sessions. The evidence produced by one subject is certainly not enough to give real support to Kelly's (1955) claim that taking part in artistic or imaginative pursuits has a 'dilating' effect in personal construct systems. It was not part of the purpose of this study to

examine the effect of dramatherapy on construing which had been found to be too tight rather than too loose. If our sample had contained more than one 'tight construer', we should have been able to draw some conclusions as to whether or not dramatherapy had, in fact, a normalising effect – that is, of tightening loose construing and loosening construct clusters that are too closely associated. More research is indicated in this area. Perhaps an investigation could be carried out using subjects whose construct systems were tightly organised. This, together with evidence about other aspects of personal experience apart from perceptual organisation, would provide evidence with regard to a possible normalisation effect represented by a general reduction of tension in an individual's relationship with his or her world of people, things and ideas.

The dramatherapy involved here consisted of a selection of dramatic processes arranged in what the investigators assumed to be ascending order of difficulty for people suffering from thought disorder. The result was a kind of extended 'introduction to dramatherapy'. It would, of course, be possible to design courses of sessions which concentrated on particular kinds of process – sensory perception, emotional symbolism, embodiment, creative expression, role reversal, etc – and, by comparing outcomes, discover which processes had the most marked effect upon clients' performance in certain kinds of task. Having established that dramatherapy itself is effective in producing change in the area of cognitive organisation, it would be possible to draw conclusions about which of its components is most responsible for this particular result. This would bring us considerably closer to being able to draw useful conclusions about how dramatherapy 'works', in the sense of actually knowing what goes on within the dramatherapeutic process. On the other hand, it might also be feasible to use performance in dramatherapeutic sessions as an aid to psychiatric diagnosis, in the way that Higgens does with dance–movement therapy:

Dance–Movement Therapy and Schizophrenia

There is evidence from psychiatric surveys, neuropsychological tests and brain imaging studies that movement disorders are associated with the central features of schizophrenia, particularly the fragmentation of personality and thought disorder.

The major objective of this study was to test the hypothesis that Movement Assessment of prelingually deaf subjects has the potential to differentiate those carrying a psychiatric diagnosis of schizophrenia

from those with non-psychotic problems. Six subjects were videotaped in an interview which included sign language communication and a movement sequence. The tapes were shown to an experienced Dance–Movement Therapist who was blind to the history and medical diagnosis of the subjects. The qualitative aspects of the movement were analysed using the specialised Laban analysis technique originally developed for dance notation and reconstruction. Although previously used in management studies, psychoanalytic research with infants and ethnographic studies, this approach has had limited application to psychiatric research.

Those subjects carrying a medical diagnosis of schizophrenia were all identified as psychotic from the movement analysis alone. The two non-psychotic controls were also correctly identified. The movement rater made a diagnosis of schizophrenia, thought disorder or psychosis with disorganisation in three of the four psychotic subjects. The fourth was assessed as psychotic with depressed affect. This result is remarkable when it is realised that all patients were in a non-acute phase of the illness, and that two of these subjects were selected on the basis that the medical team had found them particularly difficult to diagnose. The movement analysis also produced data regarding specific deficits in these subjects which complemented reports in the medical notes for therapeutic intervention. This pilot study is the first step towards developing a movement assessment instrument for differential diagnosis in deaf psychiatric patients.

(L. Higgens 'A dance-movement assessment of deaf psychiatric patients.' In Kersner 1990, p.75)

As it stands, however, the dramatherapy experiment uses a quantitative approach to establish the degree of change in individuals' personal construct systems after experience of dramatherapy. We were measuring conceptual organisation – in other words, the actual degree of closeness to or distance between groups of ideas ('constructs'). This was not a matter of individual or corporate judgement on the part of the investigators but a statistical process of recording the number of times an idea was associated with another idea, how many ideas were clustered together and the degree of association of idea clusters within a specific perceptual task. We were not drawing conclusions about the ways in which particular subjects perceived particular photographs – that is, their judgements as to whether the men and women portrayed were either more or less 'kind', 'honest', 'sincere', etc. We were not even

concerned, for the purpose of the experiment, to find out which constructs they associated together by ranking them in a similar way, either in corresponding or reverse order (although this would have produced valuable information about their own feelings and opinions, of course). We were only interested in the amount of association, the number of associated constructs and the degree of closeness, measured by the frequency of their occurring compared with others within a limited number of options (six in this case). The degree to which a photograph was judged to be either more or less 'honest' or 'stupid' provided an ordinal scale – that is, it registered which photograph might be taken as less 'stupid' than the next, or 'kinder' than the next – but it could not say for certain to what precise extent these differences occurred. (For instance, in a set of photographs ranked from 1 to 8 with regard to 'meanness', number 1 may have been judged to look exceedingly mean, number 2 almost as mean, numbers 3–8 not really mean at all, so that it was difficult for the person judging to decide how to rank them.) What this experiment was assessing could be measured on an interval scale, concerned with finding out the number of occasions something happens and ordering them numerically, so that number 4, for instance, is always twice as far from zero and number 2, and personal judgement does not come into it.

This is important, of course. Not only is it the ground on which our experiment's claim to be scientific ('measurable', 'replicable', independent of changing circumstances) stands but it also reveals some of the drawbacks associated with this particular stance. By narrowing itself down in order to focus on something it can measure in a quantitative scientific way, it intentionally disregards things about the people it is looking at which would help us to understand them as people. There is no suggestion, for example, that the information about subjects' personal world views provided by the picture-ranking test should be studied for content as well as intensity and consistency. The fact that one subject might associate 'kindness' in a one-to-one way with 'stupidity' and see it as almost the direct opposite of 'sincerity' would surely tell us something of real value to us if we wanted to relate to this particular individual as a person. The thought disorder test actually possessed a richness of resources which it itself chose to ignore.

There is not only waste here, however. There is also a kind of timidity. The quantitative approach is a defensive strategy. In order to preserve its own view of what can be said to be scientific, it sets out to defend itself against two principal threats: the first about reliability, the second about validity. The first

attempts to answer the question: How can what I say about a few be taken as equally true about the many? The number of examples that I can observe and draw scientific conclusions about is limited. Even if I am able to take advantage of the 'information explosion', the data I can receive from the Internet does not carry with it permission to experiment with entire categories of human beings in order to discover how they will all behave in a particular set of circumstances. On the other hand, if I can secure the co-operation, by fair means or foul, of a small group of the kind of people whose behaviour I want to study, and then can demonstrate by statistical means that their reactions and experiences are typical of people of this kind in these circumstances, I have managed to draw a useful conclusion about that kind of person. Useful and mathematically respectable – that is, 'reliable'.

This leaves me with my other problem, which concerns the validity of my reasons for saying that what happens in my experiment and leads me to draw the conclusions I do does so for the reasons I have given. According to the experimental paradigm which underlies the scientific approach to the study of anything at all, I concern myself with removing the validity of alternative explanations of whatever it is that has happened. There can be no other reason for this effect other than the one that I put forward myself. When one considers how many factors may actually be operating in any human situation at any one time, this appears to be an impossible task. Experimenters deal with the inbuilt validity threat to any experiment by the process of randomisation. This corresponds to the use of the statistical approach in order to extrapolate from a small sample and generalise to a 'parent' population. Rather, it is the mirror image of that particular technique because it aims to increase the effects of chance rather than statistically control them. In a randomised sample existing order is disrupted so that anything at all could be the case and markedly abnormal components of the sample will balance each other out.

These two precautions, statistical generalisation and randomisation, are built into the quantifying approach to research. They are automatically included. Both are, in fact, generalising approaches which cut across the specificity of research into actual cases, real people and contexts. In order to obtain the kind of result desired, the parameters of research are firmly established in advance, so that nothing which occurs after work has commenced will interfere with the final outcome. For instance, it will be taken as self-evident that whatever has, or has not, happened to whatever was

being examined in this experiment would, or would not, have happened to everything (or everybody) of that particular kind in these particular circumstances everywhere. Also, it will be accepted as believable – indeed, necessary to be believed – that nothing else apart from the circumstances in question, carefully chosen beforehand, will have had any effect on the thing or person in question. Once these matters have been settled and the experimental 'suspension of disbelief' indented for in the accepted way, the experiment may safely begin. When it is over, something will have been learned; a question or questions will have been answered in a way that is scientifically acceptable.

It is important to realise, however, that this is all that will have been learned. The quantitative framework acts like a straitjacket: in these circumstances this is all that could have been learned. Having decided in advance precisely what questions were going to be asked and how they were to be presented, no other questions are valid, which means that no other information can be received. The quantitative approach can be a way of not learning things (Maxwell 1996; Robson 1993). Situations and people change all the time. It is entirely characteristic of them to change in ways that are unexpected and have not been adequately accounted for. This kind of experiment can be adapted to cope with numerical transformations – the effect of an outbreak of flu among the patients attending a GP clinic, for instance, or a change in policy on the part of people in authority requiring the scope of an investigation to be widened by doubling the number of subjects included in it. What it cannot cope with is qualitative changes – shifts in perception brought about by events that were not or could not have been 'controlled' (that is, taken account of in advance). Although it can measure the behaviour resulting from attitude changes or altered ways of understanding and feeling about the world, it has no way of discovering what such changes were like – or even, if they were unexpected, how they came about – because any information supplied by the people being examined will be considered either irrelevant or actually dangerous, because, for the purposes of quantitative research, uncontrolled variables – taking a sudden dislike to the experimental process and everything to do with it, developing a migraine or being involved in a minor road accident, etc. – may not be taken seriously for the sake of the integrity of the experiment. Indeed, it could be said that they don't actually exist, having been randomised away at the outset.

The main problem with quantitative design is quite simply the amount and importance of the things you do not learn from it. How can we overcome this so that we are able to find out more about what is really happening? In the next chapter I look at an approach which combines some aspects of qualitative, or process, research with a quantitative concern for the measurable. This investigation also used a 'Kelly grid', but in an ideographic rather than a nomothetic way. In other words, personal construct techniques are used to compare feelings and perceptions rather than to record the number of times a test produces a particular kind of cognitive response in those subjected to it. However, the aim is to compare the extent to which some kinds of subjective relations occurred in relation to other kinds by setting up an ordinal scale of values. This approach is described as 'evaluative'. An example of its use is given in the next chapter.

Reading List

Bannister, D. and Fransella, F. (1966) 'A grid-test of schizophrenic thought disorder', *British Journal of Social and Clinical Psychology 5*, 95–102.

Grainger, R. (1990) *Drama and Healing*. London: Jessica Kingsley Publishers.

Guilford, J.P. and Fruchter, B. (1973) *Fundamental Statistics in Psychology and Education*. Tokyo: McGraw-Hill Kogakusha.

Leek, R.W. (1997) *Experimental Design and the Analysis of Variance*. London: Sage.

Lewis-Beck, M.S. (1993) *Basic Statistics*. London: Sage.

Lewis-Beck, M.S. (1993) *Research Practice*. London: Sage.

Lewis-Beck, M.S. (1994) *Experimental Design and Methods*. London: Sage.

Pett, M.A. (1997) *Nonparametric Statistics in Health-Care Research*. London: Sage.

Robson, C. (1973) *Experiment, Design and Statistics*. Harmondsworth: Penguin.

Sheridan, C.L. (1979) *Methods in Experimental Psychology*. New York: Holt Rinehart and Winston.

Evaluating Therapy by Number

This chapter concentrates on approaches to evaluation which set out to pay more attention to the actual processes involved in personal healing and use mathematics for arranging and ordering data rather than for the precise measurement of difference. The main example employs repertory grids, a technique usually associated with personal construct psychology.

Repertory Grids

Repertory grids are a way of ordering the information about people and things that we habitually use in order to understand them and so make sense of our personal environments. The grid itself relates 'elements', the different parts of an overall mental picture (a tree, a postman, a piece of music, Tuesday afternoon, an inspiration, toothache, or whatever else figures at a given moment), to 'constructs', the qualities or characteristics we use in order to build our picture up and make overall sense of it. In other words, constructs are used to create a relationship between and among elements. We can discover some of the constructs that a person uses to organise their own personal world simply by asking them why they think a particular thing is related to something else. The kind of answer we get will vary, of course, but at some point it will almost certainly contain the words 'both' or 'neither' – 'Because both things make me nervous', or: 'Well, neither of them goes swimming on Thursdays.' George Kelly, inventor of the personal construct psychology, described a construct as a way in which two or more things are alike and *thereby* different from a third or more things.[1] This kind of association by dissociation is something we use whenever we try to make sense of what we think or feel about, or expect from something or someone.

[1] 'In its minimum context a construct is a way on which at least two elements are similar and contrast with a third.' (1963, p.61)

They are the way we currently anticipate events because they remind us of what we believe is likely to happen in any particular set of circumstances. We can change them, of course, and, when they are changed, they can change us.

According to Kelly, constructs are 'the transparent patterns or templates which man creates and then attempts to fit over the realities of which the world is composed' (1963, p.9). Personal construct systems are the organised hierarchies of constructs which provide an individual with his or her own personal way of forecasting what is likely to happen, so that she or he may react in a way that they decide is appropriate or effective. Some constructs within a personal construct system are more important than others to the way in which the system holds together. The investigation into thought disorder described in the last chapter concentrates on the number and importance of these. Firmly established 'core' constructs represent the ideas and feelings which dominate our personal view of, and reaction to, life. They are our principal criteria for meaning and value, and, consequently, for action in the world. They occupy a position in our system which is superordinate over constructs 'lower down' and less important, which have to change as the environment in which we live changes, adjusting to altered circumstances in order to take pressure off the core constructs which give the system its particular character, the things we think of as being really us – in other words, the principles and practices which we consider to constitute our unique identity. Changes at this superordinate level affect the integrity of the entire construct system, which, after all, is organised with reference to it – either more or less directly, according to the level of a construct within our personal construct hierarchy. In other words, we are willing to alter our ideas about things that do not matter so much to us in order to protect the integrity of our hold on things that do.

As part of a reference system, constructs are not things themselves but the significances we attach to things. To construe something as having personal importance is to validate everything that follows from it as being more or less important. Symbols of personal meaning occur high up in the construct hierarchy; they have many dependent constructs so that the whole system is infused with meaning (Bannister and Fransella 1971; Burr and Butt 1992; Epting and Landfeld 1985; Kelly 1955, 1963). This means that throughout the whole system there will be references to an overall meaning. For the system to hold together at all – for it to be a personal construct system – this meaning must be present at its centre and implicit in each of its parts. If a construct's literal reference (to an actual person, tree, city, story, etc.) becomes

closely associated with a core of personal significance, the nature of the construct is transformed – it, too, becomes symbolic and consequently able to validate its own associated constructs. In this way the scope of the system is widened, making it a more effective way of making sense of life – as in parabolic narratives and sacramental signs.

In terms of the present investigation this is important. It means that personal construct theory is able to give an account of the way that spiritual experience is tied in with ordinary practical living and the planning of our daily lives and the most prosaic and 'ordinary' actions we perform.

A Quantitative Investigation Using Estimated Values (Adapted from Grainger 1995)

In this example measurement depends on an ordinal rather than an interval scale, in which values are apportioned according to personal judgement rather than an objective external criterion.

An Investigation into Dramatherapists' Attitudes

Eleven dramatherapists, selected at random from the British Association for Dramatherapists' membership list, constructed 'repertory grids' as a way of establishing the degree and kind of significance they attached to their own ways of evaluating dramatherapy. It was hypothesised that categories associated with spiritual values would be included in their grids and that these would play a significant part in the way the grids themselves were organised. This proved to be the case.

INTRODUCTION

A repertory grid is a mathematical comparison of the ways in which individuals make sense of their own personal worlds. People use mental constructs to organise what is happening so that they can refer to what has already happened and be more or less prepared for whatever may happen next. In a grid elements of the different parts of an overall mental picture or view of life are related to one another in terms of, or with reference to, the mental categories an individual person habitually uses in order to separate things or people he or she perceives as different from each other and associate those she or he perceives as in some way similar. Constructs are our mental files and elements are the material we accommodate in them. The

theory behind this view of human cognitive behaviour was elaborated by George Kelly (1955, 1963 and see preceding section).

METHOD

Subjects

The dramatherapists (Ss) in this sample were asked to choose 12 elements from a list of 29 things associated with dramatherapy. This list had been compiled by the investigator himself, a dramatherapist of ten years' experience, as a result of conversations with six registered dramatherapists in current practice, lasting over a period of one year. They consisted of techniques, interpersonal processes and types of subject matter or content familiar to all dramatherapists.

Procedure

The dramatherapists in our sample were instructed to choose twelve elements which they were themselves familiar with. They should not attempt to order the elements they had chosen. Constructs were then elected from the chosen elements, in accordance with the method described by Kelly – that is, the first three elements on a S's list were compared in order to determine what it was that, in the S's judgement, distinguished any two of them from the third. This distinguishing factor was recorded as the first of the S's constructs. This process was repeated with regard to successive triads of the S's elements until a list of twelve constructs had been elicited. The elicited constructs were then drawn up in the form of a grid along with the twelve elements.

Ss proceeded to 'score' elements in terms of constructs, using a scale of 1 to 7 (1 = highest construct score for a particular element, 7 = lowest score, 4 = neither high nor low). For example, a S who had selected 'fantasy journey' from among the list of elements, and whose constructs included 'symbolic', would probably put 1 at the point in the grid at which the two things coincided. This resulted in each S's case in a grid showing his or her relationship scores between elements and constructs. This could be used to find out how strongly each individual associated a particular person, idea or thing (element) with a particular way of assessing people, places or things (construct). Because of the grid arrangement, the relationship between elements and constructs is clearly shown. We can gauge the degree of similarity between and among constructs – in other words, the degree of association between individual constructs, and the degree of similarity between one person's construct groups and those of someone else. In this way, we can see how closely an individual's ways of making sense of the

world (construing) hang together, referring to and influencing one another to build up an overall reference system. In particular, we will be able to form conclusions about the constructs and kinds of construct that are in a dominant position within a dramatherapist's own view of dramatherapy.

Next, individual rank orders showing the extent to which elements fulfilled the criteria chosen by each dramatherapist were compared in order to discover the degree of correlation between constructs. The two constructs which were seen to have most constructs closely associated with them while remaining distinguishable from each other – that is, the central construct of each of the two largest construct 'clusters' in each individual grid – became the axis of a graph showing the most important constructs for a particular dramatherapist.

Finally, the composition of the overall list of constructs used in the S's individual grids (and graphs) was subjected to close scrutiny. There were found to be a total of 110 constructs. The group of dramatherapists responsible for choosing the original list of 29 elements of dramatherapy selected constructs which they themselves considered to be in some way or other associated with spirituality. These made up almost half (49) of the longer list. Constructs were included in the 'spirituality' list if they fitted into one or other of the following categories:

(a) personal relationship; love and understanding between people

(b) morality and personal responsibility; ethical awareness

(c) things (ideas, feelings, presences) reached out for but not grasped (e.g. Robert Browning's 'or what's a heaven for?')

(d) a sense of human destiny; an overriding purpose in life involving the transcendence of present experience.

RESULTS

These categories were seen as applying to 49 out of the 110 constructs supplied by the Ss. In other words, the judges considered that there were almost as many 'spiritual' factors in the way these dramatherapists looked at their métier as factors of other kinds. Considering how many other attitudes towards, and constructs concerning, dramatherapy were available to dramatherapists, 'spiritual' categories were shown to be more central to the way in which these dramatherapists organised their awareness than factors of other kinds.

Individual graphs drawn from the data included in the grids produced by dramatherapists showed that the largest and most close-knit 'clusters' of constructs were associated with these 'spiritual' constructs. In statistical terms, these particular constructs 'accounted for 44.6 per cent of the total variance' (44.5% of the total number of constructs). Most cases revealed a higher degree of involvement in, or concern with, issues judged to be 'spiritual' than those which were not considered particularly relevant to spirituality.

The group of constructs representing metaphor and symbol ('metaphor', 'projection', 'symbolic story', 'symbolic play', 'archetypes', 'symbolic use of media', etc.) made up 12.7 per cent of the total number of constructs (14 out of 80, including reduplications of constructs occurring in more than one person's grid). Using a T-test, this result was found to be statistically significant at the 0.05 level of significance ($t = 0.176$).

SUMMARY

The results show the importance attached by dramatherapists to factors in their ways of construing their approach which are associated with spirituality and spiritual awareness. Constructs connected to symbolism play an important or even a definitive part in the final result. Because of the importance of symbolism for the expression of spiritual awareness or experience, this would seem to provide evidence of the spiritual nature of dramatherapy. The use of a parametric test to measure the numerical significance of 'symbolic' constructs would seem to be justified by the overall normality of the data. (As was expected, the dramatherapists tended to agree with one another on many things about dramatherapy!) On the other hand, the numerical data refers to an ordinal rather than an interval scale and must be seen as an indication of Ss' preferences in the ranking of elements with regard to constructs rather than any kind of objective properties belonging to the data itself. Similarly, the choices made by the judges, first, of elements regarded as characteristic of dramatherapy and, second, of constructs considered to be spiritual in nature, reflect personal opinion rather than the measurement of public reality. An important fault in the overall design was the absence of any attempt to measure the degree of unanimity achieved by the group of dramatherapists carrying out these tasks. 'Spirituality' itself is obviously a word with many interpretations. Only the judges know how much or how little the concept was stretched in order to include more constructs and attract more data.

Thus, from the point of view of quantitative research values, the investigation may be criticised, both for design and execution. All the same, as we shall see in the next chapter, it also had some very real virtues. Some of the things that were wrong with it are particularly clear examples of the problems inherent in the attempt to carry out qualitative research projects. On the other hand, the choice of a personal construct approach bears witness to a genuine desire to investigate what is actually going on in the decisions and choices people make (and other people are affected by) in real-life situations of an extra-clinical kind. An alternative way of investigating therapists' attitudes to their own work is given below:

A Questionnaire Approach: Quantitative, Qualitative Data

Interest was drawn to the part played by the origins of an interest in art within art therapists' occupational motivation. Reviewing the relevant literature had revealed only one research-based study which had involved talking to living artists about their artistic and personal development (Rosenberg and Fleigel, 1965). I had been fascinated by their descriptions of pivotal influence during the childhood and/or adolescence of the artist in terms of encouragement and modelling. Using the work of Rosenberg and Fleigel (1965) and Henry, Sims and Spray (1971) (who research, amongst other issues, the occupational motivation of psychotherapists) as a framework, a lengthy questionnaire was designed which was completed by art therapy and art teacher students at the beginning of two consecutive academic years.

The numerical data revealed general patterns in the data. An interest in art emerged astonishingly early for many of the respondents, ranging from '0 ... >' to the age of 16, the mean age for each student group being 6½ years for the art teacher students and 8 years for the art therapy students. The greater majority of both groups experienced support and encouragement for their early interest in art from an adult 'significant other', although notably more art teacher students had such a figure within their immediate family. Coupled with more parental encouragement and contact with (usually) male figures who had a professional engagement with art, the art teacher students were seen to have had significantly greater positive influences at home *vis-à-vis* art than did the art therapy students.

However the qualitative material revealed a lot more subtlety about the origins of the students' interest in art. Although many respondents

had referred immediately to the importance of their 'significant other', others spoke of being captivated by the way the world looked, by the art materials and by the activity itself. A third group referred to what can only be described as a kind of escapism, either into a fantasy world or to a safe place where feelings could be made concrete and explored. These three apparently discrete types of origin of interest – arising for the encouragement the artists receives, their talent and 'love affair with the world' (Greenacre, 1959) and the individual's pathology – were clearly and quite unexpectedly present in the qualitative data. [In the paper Gilroy described the struggle with evaluating the qualitative data, fluctuating between 'measuring' the material (and failing miserably) and, rather more successfully, simply describing and loosely categorising it.]

(Andrea Gilroy in Kersner 1990, p.75)

The example of mathematically evaluated arts therapy research given here is taken from dramatherapy. This does not mean, of course, that the other arts therapies always avoid approaches that are traditionally scientific or, indeed, that dramatherapy has concentrated on them. In her catalogue of research projects published in 1993, Payne lists several designs aimed at this kind of measurement undertaken by other branches of the arts therapies. Among arts therapists, for example, she mentions work done by Dalley (1977), Donnelly (1983), Nowell-Hart (1985), Killick (1987), Chou (1990) and Perry (1991); for dance–movement therapy: Payne (1978, 1980); and for music therapy: Hoskins (1982), Muller (1986), Van Colle (1988), Wigram (1988), Lawes (1988), Lawes and Woodcock (1989), Odell Miller (1989), Rogers (1989), Pavlicevic (1990), Toolan (1991) and Hopper (1991). Details of these studies can be found in Payne (1993) pp.231–250. Three of them are single-case studies, which compare data collected at successive stages of the investigation (Lawes and Woodcock; Toolan; Hopper).

Reading List

Burr, V and Butt, T. (1992) *Invitation to Personal Construct Psychology*. London: Whurr.
Fransella, F. and Bannister, D. (1977) *A Manual for Repertory Grid Technique*. London: Academic Press.
Kelly, G. (1963) *A Theory of Personality*. New York: Norton.
Payne, H. (ed) (1993) *One River, Many Currents: Handbook of Inquiry in the Arts Therapies*. London: Jessica Kingsley Publishers.

The Qualitative Approach

The Research Paradigm

In the investigation which has just been described, the use of personal construct grids allowed the investigators to discern something of the quality of human experience – other people's and their own. This approach was designed to reveal both the kind and the intensity of meaning that dramatherapy possessed – primarily for the subjects, but, as it turned out, also for the judges. Personal construct psychology regards any understanding we have of the experience of other people as dependent upon the way in which we understand ('construe') our own. As George Kelly puts it: 'To the extent that one person construes the construction processes of another, he may play a role in a social process involving the other person' (1963, p.95). Research into human behaviour cannot possibly avoid being construed as a 'social process'.

The acknowledgement of the personal participation of the judges in the observation and assessment of other people's experience is the hallmark of qualitative research. The judgements involved in this kind of research investigation are experiential ones. They are judgements of experience by experience. This means that they are ideographic rather than nomothetic, recognising the fact that there is no external, 'objective' rule we can use to measure the value – however one interprets the word – of things that happen within human relationship – by which we mean events taking place 'between man and man', to use Martin Buber's phrase. Nor can we estimate with any kind of mathematical precision the exact stage a rational process has reached. The kind of ruler needed for such measurement does not exist. We can record these things but the reproduction bears a questionable resemblance to the original and any resemblance we are able to recognise is a reflection of ourselves, any message received is our own translation rendered into our own personal language.

The language we use to describe these experiences of experience are full of meaning for ourselves, some of which other people can key into their own meaning system. From the point of view of congruencies that are at all exact, however, this way of communicating remains an inexact one. In other words, contrary to an unspoken belief we find ourselves subscribing to, we can never say what we mean about experience in terms that add up to form the kind of public sums that science requires.

When we speak of experience, we measure it in terms of 'more' and 'less'. The important thing to recognise, however, is that this does not prevent us from ascribing numerical values to 'more-ness' and 'less-ness'. We can rate our experience within imaginary parameters, giving ourselves and other people marks for possessing this or that quality of experience or perception to this or that degree (on a scale of 1 to 7, perhaps), but this kind of exercise is always an assessment on a basis which remains arbitrary. On this kind of scale we may use numbers, but not in any way in which they will really add up. If, for instance, I rate my own anger or your resentment or someone else's determination on this kind of pseudo-mathematical scale, how can I (or you or anybody) be sure that my '2' is twice as much as my '1' in a way that allows it to be exactly half as much as my '4' and two thirds of my '3'? However I work things out, I will always be using a private scale – it isn't only the position on the scale taken up by the object of my study that varies, it is the actual scale itself. My scale of measurement remains different from theirs and anyone else's. When people use their own personal construct system to make statements about other people's systems, the way that they evaluate these statements is personal by definition, even though it may employ the language of number to express itself.

Unfortunately, however, to use number at all implies the kind of objectivity that studies of real human experience aim for, even though by doing so they run the risk of missing the target altogether. When rank ordering represents personal judgement according to a private scale of values, it gives a spuriously scientific appearance to the kind of research whose value and purpose does not depend on mathematically precise measurement. In itself, ranking is an indispensable tool for the communication of information about the quality of personal experience – both for experimenters and subjects. As such, research into how human beings experience the things that happen to them in the world is always likely to involve using ranks of some kind or another and, this being so, individual items will go on being rated with regard to their position in a rank order.

This, however, is to do with discriminating between, not measuring. Qualitative research enables us to look at things in ways that can't be measured – not, at least, in ways that are directly scientific. There is an important difference between measuring how many times somebody does something – in the case of our first investigation, performs the mental operation of associating groups of data (rank orders) – and exercising personal judgement in order to assess or evaluate the quality of an experience – as in the second investigation, where the judges undertook the responsibility of characterising Ss' personal judgements. In this case the public nature of the grid approach is seriously undermined by the private nature of the judges' ways of ordering their perceptions. Certainly, a way of measuring the degree of unanimity achieved by the judges in their definition of spirituality should have been included within the experimental design to begin with.

As I said in Chapter 3, qualitative research concerns itself first and foremost with the investigation of how things happen. Certainly, this must involve paying attention to the questions about the extent to which they happen, because the processes we want to study have been identified as important because of their outcome and we need to demonstrate their importance by drawing attention to the degree of change that they have brought about. In quantitative terms, this means concentrating on factors in the situation which can be singled out with some certainty as responsible for discernible amounts of change. The urge to isolate causal connections so that particular events may be reliably demonstrated as always giving rise to other equally recognisable events involves an attitude to processes which discounts genuine involvement in whatever it may be that is really happening. What actually happens in the research process itself – as distinct from the process being researched – is straightforward enough: I form a theory as to why something or other happens and I manipulate the environment in ways which I expect will have the same outcome. If this turns out to be the case, I conclude that what has happened in the artificial circumstances I have put together is the same thing that happens and will always happen within the environment which is natural to it. Of course, I may have stumbled on the key causal factor. On the other hand, I may not have done. But, either way, I will conclude that my theory was and is correct.

What can happen, of course, is that I am so distracted by my preoccupation with the theory–outcome linkage I have inherited from generations of experimental scientists that I neglect to test any other theories

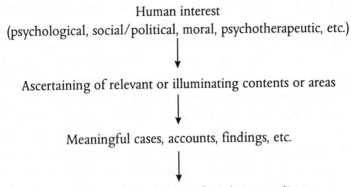

Human interest
(psychological, social/political, moral, psychotherapeutic, etc.)

↓

Ascertaining of relevant or illuminating contents or areas

↓

Meaningful cases, accounts, findings, etc.

↓

Conclusions and evaluations for relevant audiences

Figure 6.1 The Qualitative Approach to Research

or look for explanations of a non-theory-based kind. In fact, I neglect to *look*. The qualitative approach to investigating events and processes benefits from not being so theory bound, in the sense that it concentrates not on the process of research so much as on whatever it may be that is being researched. Despite the scientific pretensions of quantitative research, the qualitative approach is actually more object centred. Paradoxically, it manages to fulfil this genuinely scientific objective by taking due account of the subjective process which governs the relationship between a process itself, whatever this may be, and those involved in the effort to understand it.

The processes involved in qualitative research – its 'research paradigm' – are set out in Figure 6.1. The methods involved include observation, participant observation, interviews, documentary evidence and content analysis.

Background and Context

In fact, as several contemporary writers have pointed out, most research involves both quantitative and qualitative forms of enquiry: 'The best often combines features of each. In the same research project, some data may be collected that is amenable to statistical analysis, while other equally significant information is not.' King, Keohane and Verba (1994) go on to write of 'a creative process of insight and discovery, taking place within a well-established structure of scientific enquiry' (p.18). It is vital to point out that such a structure is an inalienable feature and precondition of good

qualitative enquiry. Quantitative and qualitative research should never be thought of as opposites but rather as the right tools for performing two different kinds of job. The matter to be investigated by the latter is, generally speaking, subtler and more global, less easily recognised and isolated than the kind of question investigated by the former, which means that different kinds of research strategies must be employed. I shall be making this point again later in this book but for the present I begin my discussion of qualitative research strategies by establishing the fact that they are strategies, approaches carefully devised to mirror the truth about the phenomena they are concerned with. There is nothing particularly scientific about using an approach to something or someone which entirely misses the point about them. Qualitative research does not eschew science. Instead, it tries very hard to extend the area in which a scientific approach may be usefully employed.

Having said this, the fact remains that the strategies employed by qualitative research are not only less quantitative, they are different in kind. Nowhere is this more obvious than at the very beginning, in the first stages of the investigation. Qualitative investigations 'start from somewhere else'. In other words, the research question 'What are we going to investigate?' may not be answered immediately. Indeed, it may not even be asked – not in any specific way, that is. The aim may be to gain more understanding of a whole interconnected situation, a cluster of interrelated phenomena comprising a perceptual context. It is unlikely to be obvious which aspects of the whole should be concentrated on first, which things about the situation may actually turn out to be the key to it. One definite advantage of this kind of approach is that it certainly makes it much harder for researchers to waste valuable time barking up the wrong tree!

At this stage of the investigation the research area should be looked at in as many ways and from as many angles as possible, so that actual research questions may begin to emerge. In a way this constitutes an extra stage in the total research process because quantitative investigations tend to begin with the researcher arriving on the scene already knowing exactly what is to be researched, what precise questions are to be answered. This may not always be apparent from the way in which the introduction sections are written, the number of relevant issues mentioned, the authorities cited and discussed, the painstaking description of previous research. There is a definite purpose in all this, of course, and it is to root the present research in soil that is already well prepared for it by locating it within an established tradition of investigation into this particular subject. From this point of view, the aim of quantitative

research is not to break new ground but to extend the frontiers of knowledge in as safe and conservative a way as possible, and this must be made clear from the very beginning. The kind of exploratory work with which the qualitative paradigm gets under way may have been done beforehand – the point being that it is not considered to be an integral part of the investigation itself. Lateral thinking of the kind recommended for the first stage of a qualitative research investigation is anathema to the experimental tradition!

On the other hand, it is part and parcel of the process of understanding connections which are not linear but multidimensional and multi-directional – as, for example, those constituting the subject matter of research into any kind of interpersonal event or sequence of events, any human context whatsoever. The success of the investigation depends on the depth and reality of the investigator's involvement in a particular context. Even though the purpose of this kind of research is the same as that of research of any kind (to achieve as clear and precise an understanding as is humanly possible), the kind of clarity and precision aimed for in qualitative research emerges from a state of affairs which is the very opposite of the kind of focus that provides the starting point for quantitative research. The first stage in this paradigm is speculation and free-ranging exploration. This is necessary, of course, because the aim of the investigation is not to isolate an effect but to understand a process. Both these intentions must be stated at the outset of the piece of work concerned. But whereas an effect can be precisely described, a process needs a wider, more comprehensive kind of description. To put it crudely, it is easier to convince oneself and other people that effects occur in isolation or as the result of a single cause than to do this with regard to any kind of process.

In the case of qualitative research, then, we do not need to know in advance exactly what it is that we intend to concentrate on. Sooner or later, of course, we shall have to make up our minds one way or another. At this stage, however, making up our minds will only get in the way. Qualitative research not only recognises the way in which the mind arrives at its most effective decision making but it utilises this awareness in its research designs. Ideas, understandings and interpretations are, of course, essential for effective action, both individual and corporate. However, the presence of the particular has the effect of ruling its alternatives at least temporarily out of court. Although we may be quite happy to follow a line of thought to its conclusion, we need to know that we're on the right track. We need to be able to consider other ways of proceeding before we finally commit ourselves to

the process of self-blinkering which close examination makes necessary. In order to give ourselves room to look around ourselves and consider our options, we perform a mental action of 'cognitive dilation' before making up our minds on a new course of action or deciding to carry on with whatever it was we were already engaged on.

Herein lies the source of our creativity, not only as scientists and artists but also, quite simply, as human beings. George Kelly (1955) describes 'the Creativity Cycle, which starts with loosened construction and terminates with tightened and validated construction' and passes through a time of median ambiguity, in which 'the person shows a shifting approach to his problems which is often exasperating to his associates or to anyone who is trying to follow what he is doing. What makes this ambiguity meaningful ... is the person's ability to experience minimally with each transient variation, then to seize upon one of the more likely ones, tighten it up, and subject it to a major test' (pp.528–529). To try to understand anything at all by simply applying a convenient cognitive theory and testing its value as an explanation is to step on the throat of one's own creativity. Certainly, for a scientist, it is to be determined to proceed with one hand tied behind one's back.

From General Interest to Specific Concern

While taking full advantage of the mind's ability to run freely, you are, nevertheless, noticing all kinds of features of the scene you are interested in, some of which are connected, others irrelevant. In order to arrive at the raw material for focused research, some of these must be systematised to form the data for a theory. In practice it is the emergence of a theory that systematises the data, selecting and ordering whatever is available in order to justify its own existence as a plausible explanation of the phenomena. In fact, the two processes – collecting data and forming theories – always run concurrently because just as an adequate theory needs relevant data, the collecting of data also requires theoretical guidelines. Not everything that happens is going to be relevant, however broadly based our ideas of relevance may be. We always need to have some idea of the kind of direction in which to direct our gaze (Coombs 1964). The design of qualitative research, says Joseph Maxwell (1996), should represent 'the underlying structure and interconnection of the components of the study and the implications of each component for the others' (p.4). Any kind of research design is 'a sequence of decisions that the research will need to make at each stage of the research' (p.13). In qualitative

research the variety of these questions and their mutual implications must be reflected in the theory to be examined. As King, Keohane and Verba (1994) put it, 'The theory should be just as complicated as all our evidence suggests'. It may be altered in the light of new data so long as this reflects new research and not simply the abandonment of an explanation proved inadequate by the data already collected. 'We may make the theory *less* restrictive (so that it covers a broader range of phenomena and is exposed to more opportunities for falsification) but we should not make it *more* restrictive without collecting new data to test the new version of the theory' (p.22).

King, Keohane and Verba are describing the state of affairs in a particular kind of research – that concerned with enquiries into social processes – but their words are equally applicable to scientifically conducted attempts to find out what is going on in any kind of interpersonal context: 'Only by knowing the process by which the data were generated will we be able to produce valid descriptive or causal inferences.' This principle is always critically important in qualitative research, and means collecting as much data in as many contexts as possible: 'Each additional implication of our theory which we observe provides another context in which to evaluate its veracity. The more observable implications which are found to be consistent with the theory, the more powerful the explanation and the more certain the results' (p.24).

Thus, from the outset, this paradigm proceeds differently from the other, including in its scope a wider range of background material – phenomena which, because they are obviously unquantifiable, cannot reasonably form the basis of research and yet certainly contribute to its overall significance. Qualitative research aims at inclusiveness rather than exclusiveness. Like a lawyer presenting a case in court, it concentrates on aspects of the situation where truth or falsehood can be clearly demonstrated while taking care not to ignore or discount anything at all which will help build up a picture of the truth as it sees it and as it is determined we shall see it as well. However, because of this acceptance of the relevance of things that are not immediately obvious as being of structural importance to the research, the controls that have to be introduced into the qualitative paradigm in order to make it a genuine piece of scientific research, rather than simply the expression of a strongly held opinion about something, must be adhered to. In fact, because of the circumstances, they must be kept more rigorously in mind than the procedures of quantitative research.

Leaving aside rigidly mathematical considerations, they are, in fact, very similar to the quantitative approaches. At least, their intention is equally

scientific. In a sense the distinction we have been applying up to now between quantitative and qualitative is a misleading one. It is based on a misunderstanding of the way that number is used in scientific inference. Number may be used to express precise degrees of similarity and difference (as in the discussion of 'interval' and 'ordinal' scales in the last chapter). The scientific use of number is not limited by the function it performs in setting the order of things that are demonstrably present in any given situation. Number can also be used to make forecasts about the nature of things that are not yet apparent – in other words, it can be used to assess probabilities. This, of course, is the foundation of statistical procedures. In statistics number tends to be used algebraically to express balance and correspondence and to draw conclusions about things outside the scope of our immediate perception based on relationships which hold good within the world as we perceive it and are able to measure it. In statistical inference the primary use of number is as a language for understanding the unseen in terms of the seen. Both kinds of research that we have been considering up to now are based on the assumption that effective action taken towards understanding the phenomena under investigation depends upon the ability to draw trustworthy conclusions as to the probability of certain events occurring under certain well-defined conditions. Number is used in a projective, objective way to show logical correspondence and regularity within a specially ordered universe, although it has to be said that the qualitative paradigm pays more attention to the correspondence between actual and experimental universes than the quantitative one does. The fundamental purpose of a statistical approach is not to measure effects but to discern regularities and assess probabilities founded upon them. In this sense statistics can never achieve the kind of scientific accuracy that non-statisticians believe it lays claim to.

From this point of view it would be a mistake to assume automatically that the qualitative approach is less scientifically acceptable than the quantitative one. Forecasting what is not immediately apparent in terms of what is constitutes the primal act of understanding and 'scientific inference' is the process of developing definite conclusions from mere suggestions. If the method employed to do this distorts our perception of the state of affairs as it exists within the present, there is no way in which it can be considered genuinely scientific as science is defined as a rigorous account of the actual. From this point of view a qualitative approach must be preferred to a quantitative one because the world it concentrates attention on is less of an

artefact, more value being given to the reality of the human world in which the investigation is taking place. It is in areas like this that the scientific acceptability of research is actually to be discovered and not in the mere presence or absence of numbers.

In fact, of course, there is no reason why qualitative research designs should not involve number so long as they use it to bring home the underlying shape of their design and to demonstrate the logic of inferences they are drawing and not merely as a way of laying claim to the kind of exact measurement of phenomena that statistics should never give the impression of having achieved. This point is admirably brought home by King, Keohane and Verba (1994): 'In our view science and interpretation are not fundamentally different endeavours aimed at divergent goals. Both rely on preparing careful descriptions, gaining deep understandings of the world, asking good questions, formulating falsifiable hypotheses on the basis of more general theories and collecting the evidence needed to evaluate these theories' (p.37). Some qualitative research is genuinely scientific because it employs its arguments in a way that is scientifically creative, which is the way in which scientific methods must always be used when we are drawing conclusions about things which ultimately remain within the area of informed guesswork – an area which embraces all real research. Whatever differences exist between quantitative and qualitative research strategies, they should certainly not be seen in terms of the contrast between science and creativity! This is an important point to be remembered with regard to any conclusions we may want to draw about the kind of research strategies that are appropriate for investigating process and outcome in the arts therapies.

The reliability of non-statistical research subsists in the basic principles which underlie all research which can claim scientific status: 'Precisely defined statistical methods that undergird quantitative research represent abstract formal models applicable to all kinds of research, even that for which variables cannot be measured quantitatively' (King, Keohane and Verba 1994, p.6). They go on to say: 'The very abstract, even unrealistic nature of statistical models [what I have referred to as their algebraic nature] is what makes the rules of inference shine through so clearly' (p.6). As I said earlier, number uses statistical inference to understand the unseen in terms of the seen. The meaning of this for research of any kind is obvious. Description and explanation both depend upon scientific inference, which is of two kinds: descriptive and causal. Descriptive inference is 'the process of

understanding an unobserved phenomenon on the basis of a set of observations' (p.55). It involves discriminating the elements in, or components of, a particular situation which belong to its structure and are characteristic of its identity as a particular kind of situation from those which are present simply by chance. This is a process that must be carried out in both kinds of research, qualitative as well as quantitative – if we want to draw conclusions about the things we are studying we must know what constitutes the 'systematic' components of the situation regarding them. Causal inference depends on isolating systematic components in events involving change of some kind – which changes are causally produced and which occur by chance (which, for instance, are attributable to systematic elements of a particular set of circumstances, one which does not normally obtain in cases like the one under investigation).

Both descriptive and causal inference represent what King, Keohane and Verba call a 'best guess'. Qualitative research gives us an opportunity to be open about this and not cover it up by using 'sleight of numbers'! Causal inference is based on the assumption that it is scientifically acceptable to draw conclusions from observing the difference between an actual state of affairs and an imaginary one from which what we believe to be the causal factor behind a particular reaction has been somehow eliminated. This constitutes the fundamental problem of causal inference reminding us that at this basic, crucial level scientific investigation is founded on guesswork (a fact that scientists themselves have known from the beginning, of course, but one which those who are overly impressed by 'science' frequently overlook). Consequently, in any one real event we may observe y^P (an event in which a particular factor is present) or y^{NP} (an identical event in which it is absent) but never both. Causal effects can never be known but only estimated. This is true of quantitative research as well as qualitative. Quantitative research takes account of factors which have to be imagined by randomising the data that is actually available. This technique is frequently – even characteristically – unavailable to qualitative researchers, who tend to work with small numbers of subjects, or even single case studies, where random selection and assignment are either impossible or not appropriate. Instead, qualitative research concentrates on observing as many implications of its developing theory as it can. It is more important where samples are drawn from than how many of them there are. The principle underlying causal inference requires that theories should not be treated as though they were already proved before they have been tested. In practical terms this means that data to be

used in testing a hypothesis should not be drawn from examples of situations in which the effect being studied is actually present but ones where it is not, the research question being in what way must the conditions be changed in order to make it present. In the formal language of experimental procedure data should be selected with regard to the independent variable and not the dependent one because hypotheses may not be evaluated properly with observations known in advance to be favourable to them.

In quantitative research causal inference is focused upon what is hypothesised as the main causal component or agent of change, while compensating statistically for any intervening influences. Qualitative approaches employ causal inference as a process whereby conclusions are drawn about causation step by step, always taking the whole situation into account as something which must be understood in all its interlocking aspects, a 'process whereby each conclusion becomes the occasion for further research to refine and test it'. [Thus] 'through successive approximations we try to come closer to accurate causal inference.' (King, Keohane and Verba 1994, p.33) The ultimate results of this process may not be as definite or precise as those of quantitative research, but the sheer length and depth of the proceedings contribute directly to its authenticity as a way of understanding what it is that is actually happening in a particular case. King, Keohane and Verba (1994) comment: 'Finding the right answers to the wrong questions is a futile activity – interpretation based on *verstehen* is often a rich source of insightful hypotheses' (p.38).

These, then, are the principles that dominate research of any kind which aims at being 'scientific'. Because they direct the way that qualitative researchers regard the facts at their disposal, they also control theory formation. Because it concentrates on accuracy of aim rather than force of impact, qualitative research theorising tends to be progressive rather than fixed at the beginning of the investigation, before any data has been collected as it is in quantitative research. This has definite advantages with regard to achieving a genuine 'fit' between the processes to be described and those used to describe them. For instance, qualitative research encourages investigators to collect more observations of the things that are implied by an emerging theory as it emerges, thus providing extra material which can be used in evaluating the theory once it has been identified. In this way an interaction takes place between theory and data – as it does in real life where theory is part of the process of thinking and not a prerequisite of it. In the event, in any kind of research there needs to be a theoretical element to show

us where to look for the data we need and the presence of some data to direct us towards a theory that will allow us to understand it.

In this sense, then, research involves the collection of data – the systematic observation of whatever it may be that we are trying to make sense of – from the very beginning. The subject matter of qualitative research is often a context involving complex human interaction. The task of discovering other contexts to compare it with that differ from it in only one way, the particular aspect that we are concerned to examine, is likely to prove daunting – if, indeed, it is ever really possible to reproduce actual human situations in this way. The alternative approach is to concentrate on a single context and collect a range of data from it by asking repeated questions covering a wide range of topics, all of them bearing directly or indirectly on that aspect of life which is currently in question. In quantitative research single subject designs involve the repetition of measures aimed at changing the experimental conditions in ways that can be controlled. The subject matter of qualitative research does not lend itself to this kind of manipulation and data has to be generated in other ways. King, Keohane and Verba (1994) speak of qualitative research as involving 'a trade off between a case study with additional observations internal to the case, and twenty-five cases each of which has only one observation' (i.e. the one which concerns our particular research interest) (p.67). They go on to say that the single case investigation suffers from the necessity of successive interventions into the process under examination in ways that systematically distort it. On the other hand, this kind of research allows the investigator freedom to choose what he or she considers to be a typical case of the process he or she wishes to investigate, without having to use artificial ways of setting it up ('designing the experimental conditions'). Case study researchers have significant advantages: they can select a case that is genuinely representative by calling on a range of data, all of it originating within the situation itself, which serves to build up an overall picture that helps to establish this particular case as a trustworthy source of information for other situations of the same kind.

The following example of qualitative research depends on self-report to isolate and establish the subject matter. The advantage of using questionnaires or interviews, structured or otherwise, is that data can be gathered from a range of comparable sources in ways that are themselves strictly comparable. As it stands, the investigation is concerned with descriptive rather than causal inference – but it leaves the way open for attempts to discern causal links between the presence of ideas and feelings

revealed by the data and effective therapeutic intervention. This kind of approach makes no apology for its lack of any initial discrimination between various factors in the situation it sets out to examine and explore, maintaining that if its subject matter is to be really understood then too close a focus on any one of its many components will have the inevitable effect of distorting the total picture, on the integrity of which the truth about each part depends. In other words, it takes seriously the demonstrated facts about human perception. Maxwell (1996) speaks in terms of a 'prior categorising analysis' of the field to be researched, aimed at the 'identification of connections between categories and themes in an understanding of whatever it is we are looking at' (p.79).

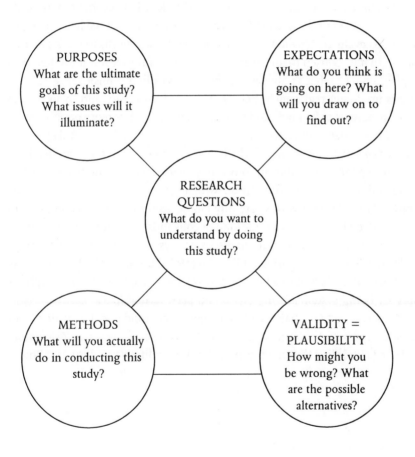

Figure 6.2: An Interactive Model of Qualitative Research Design (developed from Maxwell 1996)

The research questions are themselves the result of an interactive process which links aims, expectations, methods and likelihood together in order to arrive at a theory about what is actually taking place (Figure 6.2). Qualitative research approaches cannot dispense with theory any more than quantitative ones; theory and observation are mutually interdependent and we cannot avoid approaching any situation or state of affairs from some or other quite particular direction – clever though we may be, we lack the power to walk on more than one path at a time.

The virtue of this approach is that it allows us to shift from one path to another, so that we don't find ourselves doing what Alice did in the Looking-Glass garden, going round in circles and always ending up where we started from – a not uncommon experience in some kinds of research! Sooner or later, of course, we have to decide what we believe is really happening here in the situation we are looking at, so that we have an actual theory to evaluate. Qualitative design goes to some lengths to be as sure as it can be that its chosen theory really does represent the closest it can get to an explanation of what is always a complex and often a misleading state of affairs involving real human beings. The need for clarity and focus always exists if sense is to be made and confusion avoided – it is quite possible to go too far in our determination not to draw conclusions, so that we end up with a mass of observations, some of which are contradictory in their implications. Even so, a degree of confusion constitutes a necessary stage upon the way to a more ordered state of affairs from which important conclusions may be drawn. The process involves carefully taking your material apart in order to reconstruct it in the form of some kind of consolidated picture – which means that it is exceedingly important to discover ways in which you can file things and sort them into categories. As Robson (1993) points out: 'There is no one right way of analysing this kind of data – which places even more emphasis on your being systematic, organised and persevering' (p.377).

So far as actual analysis of data goes, the fundamental principle of research remains the same, that of comparison as a means of evaluation. Robson (1993) lists the tactics appropriate for qualitative analysis as follows.

1.	Counting	Categorising data and measuring the frequency of occurrence of the categories ('variables').
2.	Patterning	Noting of recurring patterns or themes.
3.	Clustering	Grouping of objects, persons, activities, settings etc. with similar characteristics.
4.	Factoring	Grouping of variables into a small number of hypothetical factors.
5.	Relating variables	Discovery of the type of relationship (if any) between two or more variables.
6.	Building of causal networks	Development of chains or webs of linkages between variables.
7.	Relating findings to general theoretical frameworks	Attempt to find general propositions that account for the particular findings in this study.

(Robson 1993, p.401)

Maxwell and Miller (1996) distinguish between two kinds of analysis: one which categorises themes and elements within a situation to be researched and one which looks more closely into the actual experience of those concerned in order to 'contextualise' the ideas thrown up by categorisation. Both kinds of analysis are necessary, the first for 'building theory, a primary goal of analysis', the second for 'understanding particular individuals and situations ... The two strategies need one another to provide a well-rounded account' (p.79).

Completeness of this kind is the strength of qualitative research (see Figure 6.2). This should be clearly stated at the beginning when the researchers are describing the kind of investigation this is – that it is not intended to establish the truth of a specific theory about a particular cause which always results in a definite, measurable outcome but to identify and examine certain processes taking place within an interpersonal context associated with a particular kind of human social environment; and that the difference between these two ways of proceeding is considered by the investigators to be an important one. It is the social situation that is being investigated and oversimplification in this area of life must always be

recognised as a kind of reductionism, philosophically inauthentic and scientifically inaccurate as well.

If you are writing up a piece of qualitative research, the way you introduce your subject is of fundamental importance. At this point you should be careful not to limit your own horizons too drastically. In the investigation described below, Valente and Fontana (1993) set out 'to build up a comprehensive picture of how dramatherapy is used today, in order to help formalise thinking within dramatherapy itself and to inform the attitudes of psychologists, psychiatrists, educationalists and the caring professions in general towards the subject' (p.56). They describe the background to the study, concentrating on the kinds of question suggested by the area to be researched in the light of the investigators' understanding of issues involved. In particular, this part of the research design attempts to give a satisfactory answer to the primary question as to why this particular area of human interaction has been chosen for special study. What kinds of human behaviour does it illustrate or typify? In what ways and to what extent is this kind of human action or experience associated with a particular social context and to what extent can the operative conditions existing within this context be examined without distorting their contextual identity and making them independent 'subjects of research'? Because questions in qualitative research are always contextual, this section is vital. It is, after all, the only opportunity readers have to look at the context as it presents itself to the investigators, so that they may learn what it is that has led them to choose this particular area to look at in this way and to ask these particular questions about. The following is a summarised account of the research carried out by Valente and Fontana (1993).

An Investigation into the Dramatherapy Process

What influences shape therapy? Is it possible to distinguish particular skills, role functions, professional attitudes, etc., that practitioners consider to be fundamentally important within dramatherapy practice upon which successful therapy depends? In short, what makes good dramatherapy?

Introduction

There is disagreement as to how dramatherapy should be defined. Is it a branch of psychotherapy as such? If so, what is its relationship to psychoanalysis? Perhaps it is a form of psychodrama, more closely allied to

humanistic psychology than classical Freudianism. Because it is about personal interaction, it surely must have something to learn from, and, perhaps, contribute to, object relations theory (Grainger 1990; Jennings 1990; Mitchell 1996). Dramatherapists themselves do not always seem sure on these points. In particular, they hold different views on the central relationship defining dramatherapy as a therapeutic approach, namely that between therapy and drama. Where exactly does the point of balance lie? Does therapy use drama as a medium for its own skills and insights or is drama itself directly therapeutic? These are ongoing questions within dramatherapy and any investigation into 'the influences that shape it' must sooner or later take account of their presence in the background of people's attitudes towards it. The aim of this study is to concentrate on pragmatic aspects of dramatherapy practice in order to build up a comprehensive picture of how dramatherapy is used today, and provide a measure of clarity within an overall situation that is confused and contradictory. How is dramatherapy used? How do dramatherapists set about doing their job? Valente and Fontana are particularly concerned about training and it is this that allows them to discover an area in dramatherapy on which they are able to focus clearly enough to formulate a research question the answer to which seemed capable of shedding light on the dramatherapy field as a whole: 'What do trainee dramatherapists need to know if they are to be properly equipped to meet the challenges that await them in professional life?' This is still an open-ended question, concerned with process rather than outcome. What are the operative factors involved in the actual experience and behaviour of dramatherapists at work in the field? What are the things that 'keep them going' as dramatherapists? Can these be made available for the instruction of others, notably students on dramatherapy training courses?

Methodology

Individual interviews were carried out with '12 leading British dramatherapists'. The interviews were semi-structured; during them a number of questions were presented, drawn from books about dramatherapy (notably Jennings 1987; Landy 1986; Schattner and Courtney 1981). The purpose of this was to help the investigators build up as complete and balanced a view as possible of the field to be researched and, eventually, to enable them to formulate a series of actual research questions. This turned out to be a very fruitful exercise: 'The panel of experts supplied such a wealth of information that, when the tapes of the interviews were transcribed and the responses

codified, we were in possession of an Item Bank consisting of 354 categorical statements on dramatherapy relative to [our] objectives' (p.57). This material was submitted for examination by the panel of experts so that they could adjust or expand their contributions if they felt they wanted to do so.

This material was divided into two sections: *The Theory of Dramatherapy* and *The Practice of Dramatherapy*, each section containing a number of sub-headings. This material was used to draw up two sets of questions – one aimed at determining the degree of agreement amongst dramatherapists on the importance of issues about dramatherapy that had been brought up by the panel and the other intended to gather data about the frequency with which practitioners used 'techniques, skills, assessment methods and so forth, to which the issues referred' (p.57). Out of this material the investigation put together a questionnaire of seven subsections and 273 questions. Responses were to be scored on 'a four-point equal-interval scale (from "most" to "least") for the variable concerned (e.g. "degree of importance", "frequency of use")'. This questionnaire was then delivered to the entire membership of the British Association for Dramatherapists (full and associate members).

Fifty-six per cent of those contacted responded to this approach, 86 per cent of whom were qualified dramatherapists. 'In the event, statistical analysis of results revealed no significant differences between the responses given by unqualified members of the Association, and accordingly the results yielded by the two groups were pooled and all responses treated homogeneously' (p.57).

The investigators reported that there was a high degree of consensus in the replies to the questionnaire (which 'revealed a picture fully indicative of the rich and stimulating nature of dramatherapy as at present constituted', p.58). In their report of the investigation they concentrate on three of the original subsections of the questionnaire:

- the role of the dramatherapist
- the qualities of the dramatherapist
- the theoretical influences upon dramatherapy.

Analysis of Results

Respondents had ranked the issues presented to them in order of the importance they personally attached to them. The means of these scores from each subsection were themselves ranked on a four-point scale, from 1 to 4 (1

= 'the most important issue to me'; 4 = 'the least important issue to me'). This was carried out so that the investigators might gauge 'the relative importance attached by the sample [of dramatherapists] to each of the issues contained in the respective sub-sections'. This, of course, was the information they wanted to gain from the enquiry, for 'from the point of view of professional training it is clear that those issues accorded the most importance should form the basis of teaching objectives and syllabus content' (p.58).

Conclusion

The rest of the report concentrates on a discussion of those functions and characteristics of the dramatherapist's role, qualities and theory which respondents to the questionnaire (and members of the panel of experts) had said were the most important to them – and, by implication, to the profession as a whole: 'The panel of experts and the practitioners involved in our research have identified clearly those skills, personal qualities and areas of knowledge into which dramatherapists should be initiated during their professional training. Our findings therefore provide some of the scaffolding around which the dramatherapy training course should best be constructed' (p.66). The investigators point out that they do not claim that the investigation is complete but they trust that it will stimulate 'discussion and debate' within the profession to which it is addressed.

The most important part of the investigation is, of course, the section which examines the results of the questionnaire and isolates the categories with regard to the practice and theory of dramatherapy that dramatherapists themselves regard as being the most central to their work. With regard to 'role skills', the top five (out of eighteen recognised by Valente and Fontana) were: listening, observing, supporting, identifying issues and staying calm in crisis. Out of a hierarchy of 18 'personal qualities desirable in the dramatherapist', the leading five (roughly a quarter of those listed) were self-insight, motivation, empathy, sensitivity and spontaneity; while the leading 25 per cent of 'the most important theoretical influences' were listed as group dynamics, psychotherapy, theories of play, theories of creativity, child development, client-centred therapy and imagination. The writers also include two more hierarchies which they regard as playing an important part in dramatherapy practice and theory. Of these, hierarchy No. 4 – 'authorities relevant to the understanding of dramatherapy' – is headed by Carl Jung, D.W. Winnicott, Carl Rogers, Constantin Stanislavsky and Peter Brook (18 names listed), while hierarchy No. 5 – 'individuals currently important in

dramatherapy' – includes 16 names, the first of which are Sue Jennings, Jacob Moreno, Dorothy Heathcote and Veronica Sherborne.

There is no specific hypothesis to be listed here. There is, however, a powerful implication that if certain conditions apply, results will ensue that are favourable to the successful practice of dramatherapy. These conditions are claimed to involve particular kinds of dramatherapy role skills, personal qualities on the part of the dramatherapist and theoretical backgrounds or underpinnings which had an influence on their professional practice. The degree to which expert dramatherapists and the rank and file members of the profession are in agreement as to the kinds of skills, qualities and theories most likely to result in 'good dramatherapy' carries with it a strong inference that these results describe the situation with regard to dramatherapists in general and not simply the ones reached by the investigation – although this cannot be statistically proven by the method employed here (or perhaps by any method suitable for registering individual opinions and attitudes in a realistic way!). There is also a definite causal inference: not only will the things placed at the head of the lists give rise to a better therapeutic result than those listed further down but there is a very good reason to expect that they will actually result in good dramatherapy – that is, therapy defined as fulfilling these conditions. In order to avoid this circularity some kind of outcome study would have to be put together in which these particular therapeutic conditions formed the dependent variable (or variables) – a difficult task, but not nearly so hard as deciding upon the kinds of personal change occurring in dramatherapy clients which would constitute acceptable, or even feasible, dependent variables.

Broadly speaking, the hypothesis to be tested in a follow-up investigation would be that 'the categories here identified as most favoured by the respondents to the dramatherapy questionnaire would give rise to the best therapeutic outcomes' (however these were defined). The rules of causal inference require taking steps to ensure that such a hypothesis was tested by comparing these particular categories of dramatherapy practice and theory with a range of categories from which the particular values they express are absent. If only cases which are expected to produce positive change (i.e. those at the head of the list) are compared together, there will be no way of isolating and defining which categories are actually the operative ones – and what they actually do. Besides which, those variables which are the genuinely therapeutic ones may pass unrecognised alongside the ones the investigators themselves expect to be the ones responsible for therapeutic success, giving

the latter a spurious appearance of effectiveness. In technical language, observations to be tested should be taken from data which is correlated to different values of the explanatory variable and not from examples correlated to successful outcome (i.e. the dependent variable). Categories at the top of the list should be compared for successful outcome with those lower down the list. The investigators would not really know what the dependent variables were – that is, what constituted successful therapeutic outcomes – until this had begun to emerge in the course of the research (King, Keohane and Verba 1994).

The main thrust of this piece of qualitative research is not, however, to demonstrate causal inference in order to establish the degree to which something has affected something else. The main aim here is to discover what kinds of things contribute to a particular kind of outcome already established as effectively therapeutic. In other words, the study aims at understanding a process rather than isolating an effect.

Both this investigation and the one into 'dramatherapy and spirituality', described in Chapter 5, are based on decisions taken by the investigators to define reality in a particular way and then to use their definition as a measure for categorising other people's experiences and opinions. In this case the decisions were not taken by the authors without consultation (see 'Methodology – The Panel of Experts'). In the previous investigation individual judgement was directed towards deciding which constructs supplied by the investigator could be described as 'spiritual' – a subjective judgement made within possibly the most subjective area of human experience! In this case, however, decisions about the questions to be asked about the practice and theory of dramatherapy and how they were to be asked were made only after extensive consultation with people who had themselves considered these matters in depth for several years. Thus although the definition of specific areas of human behaviour – skill, personality, theoretical position – made on the part of dramatherapists as being the most important for a consideration of the nature and working of 'the dramatherapy process' and the actual questions to be asked with regard to these areas depended in the long run on individual judgement, this was as informed as the investigators could make it.

In fact, the investigation was wider and deeper than appears from the account given above, which is the one included in Payne (1993). The original questionnaire had seven subsections, not five, all of which 'have implications for professional dramatherapy training'. To criticise this kind of

study because it depends upon the judgement of the researchers is to miss one of the main points about the qualitative approach, which is more concerned with the nature and quality of human experience than with making detached judgements about a world of which one pretends not to be a part. Qualitative research is to be evaluated according to the depth of the researchers' involvement in the 'world' they are investigating and this means that their judgements are not to be regarded as of limited or peripheral interest, as if they could safely be disregarded in the presence of data whose public significance has been demonstrated. In this kind of research subjectivity is the object of attention and the 'subject matter' to be investigated is the experience of people within a particular social context. I shall be taking the idea of researcher participation further when I come to look at 'action research' in a later chapter. Already in qualitative research the judgement of the investigating team is seen as part of the investigative process and not as a handicap to be overcome by some kind of randomised arrangement of variables. Instead, individual judgements, prejudiced as they invariably must be, are balanced against each other within a format wide enough to include a genuine cross-section of the people involved in the investigation, and those involved in designing investigations work together to arrive at a consensus as to what should be included or excluded. Individual opinion and experience – human judgement, in fact – is not regarded as an embarrassment but as the only way of establishing truth which is authentically human.

As I have already said, qualitative research such as the kind carried out here enables us to look at situations which would be difficult or even impossible to understand properly by means of simple measurement of recognisable effects – for example, things concerned with the quality of human relationships and what happens between people. It concerns itself primarily with investigating how things happen rather than trying to be precise about why they do. Certainly, this involves paying attention to questions about the extent to which changes occur but it is recognised that precision in this area is not always the most important factor and that the urge to isolate firm causal connections in ways that allow them to be reproduced may, and often does, contribute to a view of process that discounts genuine human understanding of what is really happening. The danger of isolating the wrong causal factor is avoided by trying to cover as many aspects of whatever is being investigated as possible, not in order to guard against the possibility of there being other ways of explaining the situation but in order

to try to unearth as much evidence as possible that the investigators' understanding of what is taking place is a valid one. In short, evaluative research of a qualitative kind depends on subjective judgement. This is considered to be necessary because of the kinds of subject matter it deals with. It certainly doesn't mean that this kind of approach is less systematic; it may be less scientifically rigorous but it has a better chance of being relevant to the material on which it concentrates its attention (King, Keohane and Verba 1994; Maxwell 1996).

The other side of the picture is equally important, however. Qualitative research is based upon judgement rather than measurement. If it is to be taken seriously as a guide to the reality of a particular situation or context, it must be able to state that the judgements observed are representative of the positions taken by people in situations and contexts like the one studied. It must be able to do this convincingly. Like quantitative approaches, qualitative research uses statistical methods to establish degrees of probability. How probable is it that these judgements are typical in a representative sense of judgements made in this field? If a piece of research is to command respect as a reliable extension of human knowledge, this question has to be faced one way or another.

In the study just described the authors used a statistical test, the 'Kolmogorov-Smirnov test for similarity of frequency distributions' (Valerite and Fontana 1993, p.58), in order to test whether inter-rank differences were significant enough to justify the use of mean rank orders to signify the distribution of respondents' judgements in a statistically acceptable way – that is, as an indication of the distribution of opinion across a hypothetical population which would include all dramatherapists, not simply those questioned. Statistical procedures are important in qualitative research for descriptive purposes – that is, to indicate the range and applicability of the results obtained.

King, Keohane and Verba (1994) underline the special importance of being as definite about judgements which emerge from this kind of research as possible. Because the design is a qualitative one, we have to make quite sure that any elements of it that may be measured and quantified appropriately should in fact be treated in this way ('When we are able to find valid quantitative measures of what we want to know we should use them' (p.44)), bearing in mind that 'no-one cares what we think – the scholarly community only cares what we can demonstrate' (p.12). Qualitative research should be 'A dynamic process of enquiry occurring within a stable structure of rules'

(p.15), and rules which are too vague simply do not convince other people. On the other hand, it is very easy to confuse precision with accuracy, and research into process and context should never fall into the trap of being quantitative for its own sake or simply to impress the scientifically minded. King, Keohane and Verba point out: 'Inventing quantitative indices that do not relate closely to the concepts or events that we purport to measure can lead to serious measurement error and problems for causal inference' (p.44). In other words, the urge to demonstrate effects may, and frequently does, distort the effects themselves. As I suggested earlier, the genuinely scientific aspect of qualitative research is broader and deeper, more intrinsic and pervasive than the ability to be statistically significant.

Case Studies

Much research of a qualitative kind is carried out by using a case study approach in which 'Validity is seen as residing in the nature of the direct experience which the case study provides and the sense of recognition it gives in the light of past experience' (Platt 1988, p.4). This comparison of written descriptions of people and events is obviously a qualitative technique but this does not necessarily mean that it is impossible to draw quite accurate inferences concerning it about causal relationships: 'It is pointless to seek to explain what we have not described with a reasonable degree of precision' (King, Keohane and Verba 1994, p.44). For description to be useful in this way it has to be as accurate as we can make it. Colin Robson (1993) defines a case study as 'a strategy for doing research which involves an empirical investigation of a particular contemporary phenomenon within its real life context using multiple sources of evidence' (p.146). The operative phrases are 'empirical' and 'multiple sources of evidence'. Alexander George (George and McKeown 1985) sees the approach as depending for its usefulness on comparisons that are 'structured and focused', requiring data to be collected according to the same variables across the particular cases being studied. The great benefit of the method lies in its realism and flexibility. Data is studied 'on site' and in the form in which it presents itself to the researcher – that is, 'empirically'. Some researchers prefer the design of their work to emerge as part of the process of asking questions and carrying out observations. Robson (1993), however, points out that a predetermined experimental structure is usually necessary if the approach is to be used as a way of drawing firm conclusions about human interaction. This structure needs to consist of nothing more elaborate than:

(a) a conceptual framework (an idea of the sort of situation(s) you are interested in observing and the kinds of things you would consider to be important or relevant. This is not a theory about what you expect to find but a basic plan of whereabouts you intend to look!)

(b) a set of research questions (these can be quite vague to begin with, until you begin to get a 'feel' for the situation you are observing. Some may draw little information and others turn out to be key questions.)

(c) a sampling strategy (this determines how you will actually go about the study. For example, which people are to be interviewed or observed, what kinds of things they will be doing, where and at what times they will be doing them.)

(d) methods and instruments for collecting data (in general, this is by observation, participative or otherwise, or interviews, standardised or open-ended. With regard to arts therapies research, it is by providing opportunities for artistic work of various kinds.).

(Adapted from Robson 1993)

Such a structure allows the researcher a good deal of freedom within a few basic parameters, focusing the study as a serious attempt to discover things about the way people interact 'in their natural habitat' without affecting the situation in ways that are liable to distort both it and them. So long as the structure remains loose, there need be no necessity to impose it. Its purpose is a starting point for an enquiry which will generate its own procedures and decide its own ways of validating events, some of which will almost certainly defy calculation or even literal description.

Within the sphere of human relationship, poetry tends to be considerably more accurate than calculation. The case study approach to arts therapies research is particularly appropriate because it allows the artistic happening to speak for itself and as itself by producing a frame in which artistic communication is permitted to take place in ways able to preserve its resonance. Art can somehow distance itself within a case study setting as it cannot possibly do in any kind of experiment which requires each event, idea or experience to be coded in the same way, so that everything may become grist to the scientific mill.

In fact, most arts therapies research is qualitative. Arts therapists tend, on the whole, to be more concerned about discovering the processes involved in healing than measuring its outcome. Research projects carried out by art,

music and dance–movement therapists confirm the impression I myself have gained from working as a dramatherapist. Among examples of qualitative research in these areas are: art therapy – Dalley (1979), Waller (1980), Greenwood and Laylin (1987), Schaverien (1989); dance–movement therapy – Payne (1987, which also includes quantitative and action elements, 1988, 1992), Scott (1988); music therapy – Bunt (1985), Oldfield (1986), Hoskyns (1986), Levinge (1989), Sutton and Hill (1989). Some of these are case studies (Dalley, Schaverien and Bunt). Information regarding them all – and other examples of qualitative dramatherapy research – are included in Payne (1993).

In the language of research, qualitative should not be taken to mean unsophisticated. In fact, the truth may be quite the opposite. In the last ten years the use of questionnaires and rating scales in qualitative research has been very greatly assisted by computer programmes which can deal with data in ways that allow it to be compared without attempting to measure it or regard it as in itself measurable. Thus '"non-numerical" and unstructured data can be handled in qualitative analysis' (NUD IST 1997, p.1) – a good example of a systematic approach to problems of evaluation that evade our attempts at actual quantification!

Reading List

CORE (Clinical Outcomes in Routine Evaluation) (1998) *Core Systems Handbook*. London: Core Systems Group.

Cresswell, J.W. (1998) *Qualitative Inquiry and Research Design*. London: Sage.

Denzin, N. and Lincoln, Y.S. (eds) (1998) *The Handbook of Qualitative Research*, 3 vols. London: Sage.

Feldman, M.S. (1994) *Strategies for Interpreting Qualitative Data*. London: Sage.

Hamel, J., Dufair, S. and Fortin, D. (1993) *Case Study Methods*. London: Sage.

Kirk, J. and Miller, M.L. (1986) *Reliability and Validity in Qualitative Research*. London: Sage.

NUD IST (1997) *QSR Version 4, NUD IST*. London: Sage.

Silverman, D. (ed) (1998) *Qualitative Research: Theory, Method and Practice*. London: Sage.

Strauss, A.L. and Corbin, J. (1990) *Basics of Qualitative Research*. London: Sage.

Wolcott, H.F. (1990) *Writing up Qualitative Research*. London: Sage.

Action Approaches to Research

In Chapter 6 I discussed the fundamentally systematic bases of qualitative research, pointing out that because it obeys the rules of scientific inference it should not be dismissed as haphazard guesswork or mere wishful thinking. The kind of hypothesising that underlies qualitative research is exactly the same as that upon which quantitative approaches are founded, and where there is a more precise estimation of probabilities there is a greater chance that this may turn out to be misdirected.

For some researchers, however, this kind of argument cuts very little ice. If your main concern is to capture the true quality of a personal happening in order to understand more about what it is that gives it this precise quality, even this degree of scientific rigour may be regarded as an obstacle. Many arts therapist researchers see scientific aims and procedures as an irrelevance, something specifically designed to distract them from their main purpose – which is to experience the ways in which the arts therapies, or the particular one in which they are interested, function. They are likely to resist using this word in any literal sense – any sense, that is, implying a mechanical kind of causality. They would claim, in fact, that arts therapies work in the way and to the extent that human relationships 'work': you learn about them by being in them; there is no other way. From this point of view, acknowledgement of the value of the arts therapies is a matter of personal experience rather than argument. Arts therapists find themselves in Moreno's position with regard to their 'cultured critics', having to fall back on the possibility of actually involving them within the therapeutic process by inviting them to take part in the research themselves, so that academic debate may be overtaken by personal conviction.

Involvement is the main tool of an entire area of research into the human sciences that is generally known as 'action research'. Action research involves the use of as many sources of information as possible. Instead of concentrating on observations registered by an observer presumed by his or

her scientific attitude of mind to be 'detached', this approach concerns itself directly with the experience of everyone involved, both as investigator and investigated. Not only interviews and questionnaires may be used but also diaries and journals, narrated accounts of personal experiences, reports of interactions observed either overtly or covertly or both, plus the use of videos. The purpose of covert observation in research of this kind is to preserve the authenticity of interpersonal encounters whose nature would be changed by participants' knowledge that their words and actions were being studied. Here everyone concerned is both researcher and subject.

This, at least, is the intention; and those concerned with setting up this kind of investigation, the leaders of the group, go to considerable lengths to develop a shared atmosphere of trust and co-operation, so that what is lost in privacy may be recovered by a sense of solidarity with other members of the research project.

The general 'shape' of action research is as follows:

An interest in or concern about a social situation which is
shared by a group of people

↓

The group enquires into its own practices to see what light is
thrown by them on this situation

↓

Theories emerge which are used to guide the enquiry and make
it more systematic; things are seen in new ways

↓

New understanding allows problem solving in and by the
group, resulting in positive social change (and, sometimes,
personal renewal too).

The stages involved are less clear-cut and more continuous than in quantitative or even qualitative research. The process is one of the evolution of insight within a group of people who are concerned to share their experience of one another and themselves. The intention is to discover truths about relationship which can only emerge within the relational matrix itself; the method depends upon the group's willingness to examine its own processes and the techniques involved are directed to making social interaction more intense rather than isolating individual behaviour. The essence of action research is *interaction*.

The approach is often associated with the 'new research paradigm' described by Peter Reason and John Rowan (1981). This is specially designed to be 'non-alienating' and consists of doing research 'with people rather than on people'. So far as the arts therapies are concerned, the principal advocate of this approach has been Helen Payne (1993), who, with Bonnie Meekums, has written authoritatively on the subject of its advantages and the difficulties inherent in it: 'As a result of the move away from the distance of objectivity in a new paradigm approach there is a move towards knowing based on a participative and dialogical relationship with the world. An important aspect of the current trend towards a more holistic practice is that it requires deeper participation' (Meekums and Payne 1993, p.169). Payne's specific concern is with dance–movement therapy (DMT): 'Holistic DMT requires the body, mind and spirit to become involved ... Aspects of phenomena are understood deeply because they are known within a context of our participation in the whole system, not as the isolated dependent and independent variables of experimental research. This dense knowledge, called by Geertz (1973) "thick description" is both systemic and descriptive. Theory is then derived from a network or pattern of understanding' (pp.169–170).

Payne describes a way of working with DMT clients which is 'collaborative or co-operative'. This is founded on the researchers' determination to share as much information as possible concerning an investigation, with everybody likely to be affected by it in any way and at every level. As much as possible, there is a sharing of social status as well as information, researchers taking on the role of co-participant in the design and execution of a research strategy aimed at revealing the process of therapy as it actually happens rather than an imitation of the process that has been specially mounted for the occasion, something which is really an artefact produced by the research itself. This was by no means an easy task. The object of this kind of research paradigm is to undermine and, so far as possible, disarm the experimenter–subject relationship. Unfortunately, there are other kinds of structured role relationship which must be preserved in order for a particular social context to exist and be recognisable as itself. The most important and obvious of these is, of course, the client–therapist relationship on which therapy depends. For example, in the case of dance–movement therapy Meekums found that her clients resisted the presence of a second interviewer, specially provided (and trained) to relieve her from the non-therapeutic role of interviewer, and preferred to be

questioned by the therapist herself: 'In this case the "therapeutic alliance" was an aid to the authenticity of the enquiry' (Meekums and Payne 1993, p.170).

On the other hand, clients responded to the idea that the aims of therapy should be worked out among themselves in co-operation with the therapist. In order to help them to think about themselves in ways which would make such a thing possible, the therapists provided information about this kind of co-operative enquiry in the form of videos and photographs of people taking part in similar kinds of project. Obviously, the task of actually designing research involves skills that are more likely to be possessed by therapists than clients, who can be expected to be untrained in such matters and are very probably not feeling at their most able at this point in their lives. Nevertheless, the principle remains the same: what can be shared, should be. 'Full co-operation is always an ideal to strive for.' (p.170) Meekums and Payne managed to achieve therapist–client collaboration at the stages of designing research, collecting data and analysing the results, the three most crucial phases of the operation.

Active co-operation of this kind is seen as part of the research experience because it actually belongs to the therapeutic experience that is being researched. As in qualitative research, what it is that is actually being investigated emerges as the situation to be researched is lived. It is in exploring an interpersonal context that theories and hypotheses arise. Reason (1988) draws attention to what he calls 'knowledge in action' – 'the view that knowledge is formed in and for action rather than in and for reflection' (p.12). Here knowledge about relationship forms the raw material for research into relational processes and this knowledge is formed by actual involvement in the processes concerned. We learn by the things we do with and among people, not by standing back and thinking about them, drawing abstract conclusions from them but actually in the doing of them. Theoretically, Reason's view is traceable to that of Martin Buber (1958), who sees involvement and detachment as mutually dependent components of human relationship, never really separate yet never to be confused, so that any kind of genuine human understanding depends on a continual drawing close to, and standing back from, other people because the action of learning about life must be refreshed and renewed perpetually in the experience of life.

This, in fact, is how action research works. It is not simply a case of taking a practical 'hands-on' attitude to knowledge, but a philosophical refocus on how knowledge is constituted and what it originates in. Because human

understanding is indistinguishable in its effects from the events that give rise to it, things within the human context that are overlooked or discounted by traditional research assume a new kind of importance within action research. Problems of organisation and their resolution, the absence of various kinds of expertise and the ways in which this can be circumvented or even used; changes in relationship within the group and unexpected developments occurring in the world 'outside' yet inevitably influencing the way that the group as a whole and individuals within it regard the reality of their situation; the hope of a successful outcome and the fear of an unsuccessful one leading to a readjustment or a series of readjustments of what is to be construed as constituting failure and success – all of these things become elements of the investigation itself as the limitations imposed by the human context are recognised and taken account of as essential features of the context rather than distractions from the true object of research or simple breakdown of the system. In practice this means a tighter control, not on the events themselves – which would mean interfering in the nature of what was happening – but on the researchers' awareness of the significance of seemingly unimportant developments. To balance this, however, the need to treat everyone taking part as a researcher and not simply 'somebody being researched into' allows more room for manoeuvre with regard to the ways in which things are actually done within the overall research framework.

Describing her own work, Payne reveals: 'The research process was adapted to the findings at each stage, for example in the preliminary project it was found not to be conducive to the trust-building process to invite form filling as a part of the research, particularly when administered by the therapist after DMT' (Meekums and Payne, p.172) This is not so obvious as it may seem to be, particularly in light of the fact that in a previous piece of research clients had resisted the idea that somebody other than the therapist should be in charge of this more formal aspect of the investigation. It turned out to be a case of presentation and role, however – what Marion Milner (1952) calls 'frame': to have a stranger administer tests of this kind interfered with the integrity of the group's corporate role as investigators, so the job should certainly be done by the therapist as – in this sense – part of the group. On the other hand, asking formal questions could certainly not be construed as therapy, so the therapist must clearly signal to the group that she was now playing a different role while remaining the same person. This kind of role exploration carried out within the investigating group as part of the group process provides the underpinning of the group's own investigation of the

therapeutic modality. Clients' perceptions of therapy and of the relationships with other people involved in the same process, both therapists and fellow clients, begin to be seen in contextual ways and are impossible to disentangle from the life of the project.

This is what is meant, then, by 'action research' or 'researching from life'. As we saw in the last chapter, it is quite usual for those undertaking qualitative research to build up their research procedures as they continue collecting observations about a particular context or state of affairs and not to decide finally about the form their hypothesis will eventually assume until quite late on in the process of making sense of their material. The kind of approach I am considering in this chapter takes things further still. Compared with quantitative methodologies, it is indeed a 'new paradigm' and may seem revolutionary. All the same, its foundations are to be discovered in some of the attitudes and assumptions associated with qualitative research. There is, however, less concern with tracing origins of events and claiming their generalisability to other situations (with causal and descriptive influence, that is) and much more with exploring personal and group experiences in order to seize the essence of a particular situation – the one being investigated.

John Rowan on 'New Paradigm Research'

Just to remind you what new paradigm research is, let me quote Colin Lee, who said that it consisted of doing research with people rather than on people. That seems as good a thumbnail definition as any other. When I first started talking about it in 1973 I called it non-alienating research...

The piece of research I would like to talk about was published this year (1990). It is all about a study carried out around the experience of a work team which took on the humanistic approach of a fully participative action ... The book focuses on one of the least understood areas of management: the processes of working collectively. The agency being studied was a Family Service Unit in Newcastle-upon-Tyne, dedicated to the empowerment of users. But if empowerment was a good thing for the users, was it not also a good thing for the workers?

The researcher adopted a new paradigm approach from the beginning. Something of the flavour of what this meant is given by this quote from one of the women studied in this research: 'I thought I knew nothing at all about research. But I did know lots of things, and a lot of

them I've learnt from the process of being involved in this. You have the right to say to the researcher, "You don't make up the rules of the research, I make up the rules if you're gonna research me ... First of all, your research has got to be useful to me if I'm gonna take part in it. I'm not just a willing passenger; I've got the right to make up some of the questions. And I have the right to edit your material even if it means you leave out all the juicy bits that you're interested in.'"

(From a talk given at the 2nd Arts Therapies Research Conference, 1990, City University, London)

The description 'new paradigm research' is associated with Parlett and Deardon (1977), who coined it to refer to approaches designed to help researchers come to terms with contexts and situations which are difficult to categorise, either because they are exceedingly complex or because so much about them is unknown or even unknowable. In fact, it is this quality of 'quantitative opacity' which Parlett and Deardon found so fascinating – surely there should be a way of researching phenomena too intangible to be tied down by scientific definition? After all, human relationship itself is precisely this kind of phenomenon and any way of regarding it as something else is both nonsense and non-science. It is not only the intangibility of a human context which has to be taken into account but also its historicity – in other words, its basically unrepeatable nature. The paradigm shift claimed concerns the status of reason, which is no longer allowed to constitute the main tool of research into complex, interpersonal situations. This is because it has failed to shed the kind of light on human interpersonal reality it was expected to do. The kind of 'Alice through the Looking-Glass' approach to problem solving, powerfully advocated by cognitive psychologists from George Kelly to Edward de Bono, which depends on being willing and able to 'walk all round the garden' in order to reach the centre, here becomes the guiding principle of research. Whenever there is lack of definition, opportunity, stability (in the sense of things staying the same long enough to allow the researcher to 'get a grip on them') and standardised data (in other words, genuine human experience in all its recognisability and uniqueness), Parlett and Deardon recommend what they call 'illuminative evaluation', an approach concerned more with revealing wholenesses than isolating details where meaning abides only in context. Illuminative evaluation seeks illumination. Its metaphors concern disclosure rather than measurement. It is not an exclusive attitude to research, intended to discredit other ways of investigating phenomena, and quantitative elements may be included within

an overall strategy, but it depends to an important extent on the psychic functions which are allowed to come into play when cognition is not immediately dominant in our awareness. Just as in designing a building, an architect trusts his or her visual, tactile, kinetic senses and intuitive sense of how the finished building will actually 'feel' once it is up and used by real people, so a researcher must learn to have confidence in the kind of insight which comes from letting things (and people) say things to you rather than always knowing exactly what to say to them (or if you don't, at least possessing the prescribed techniques for saying something).

This, of course, is what Payne (1993) means by 'knowing based on a participatory and dialogical relationship with the world' (p.164). Illuminative evaluation consists of a five-stage process (Parlett 1983):

Setting up

Open-ended exploration

Focused enquiries

Interpretation

Report

In setting up, the area to be investigated is identified by those taking part in the investigation. This does not need to be done precisely – in fact, at this initial stage, precision is actually counter-productive. What should be decided, however, is the general direction of attention, with some idea about defining a workable area on which to concentrate. This is not a unitary idea, however. The area of attention is itself an interaction, a 'world' in flux rather than a blueprint or diagram. At this early stage, everybody involved, either as participants in the investigating team or members of the social context to be investigated, must be made as aware as possible of what is going on and encouraged to discuss thoughts, feelings, reactions and ideas concerning it. From now on both investigators and people investigated will be treated as participants.

Open-ended exploration is the stage of total immersion in the research programme. This may be an extended period of time. In contrast to

quantitative approaches, exploration is not restricted to the subject area of research, or even to techniques of investigation which may be included under the headings 'experimental design' or 'research methodology'. What is of primary interest here is the relationship between researchers and their subject matter. An overall picture is gradually built up of every aspect of the research event. It is still, at this stage, a case of learning to look at something for its own sake, engaging it in dialogue so that it may have an opportunity to speak for and about itself before we have had a chance to define it for control purposes – even the ordinary kind of definition involved in understanding things. This is the phase of the research in which not understanding is actually most valuable – by not knowing precisely where to look, we give ourselves the chance to see things we would not otherwise have been looking for.

Focused enquiries, overlapping with the previous stage as ideas of shape and purpose affect the investigating process, result in the emergence of definite themes. This is the stage where interviews become less unstructured and people involved try to make connections, leading to the interpretative and explanatory organisation of material presented to them (or originating with them). This involves rechecking previous information and diverting lines of enquiry into new directions. 'Progressive focusing' is used to reduce larger amounts of material to a format in which they can be re-examined prior to further refining. An ongoing process towards more definite conclusions provides more space for new ideas to emerge. In this latter stage of the investigation thought is being given to its final presentation as a report in a form which will clarify the process of enquiry for readers, particularly those professionally or academically interested in the area being researched. This, too, is an ongoing process, always changing with the growth of understanding that evolves from a group's developing 'experience of itself'.

Cradled in 'betweenness', the arts therapies resist the kind of control that basically denies the experience that they themselves have of themselves – the kind typified by 'old paradigm' research. This is not simply a theoretical disagreement between two models of research design. The slightest danger that a technique may actually distort the relationship between persons that it claims to understand is enough to rule it out of court for therapists whose practice consists in achieving situations in which the people concerned may be true to themselves by being true to the relationship. Only those personally involved in its practice, argues Payne (1993), can carry out the kind of research which will really throw light on the process of therapy:

'Practitioners and researchers of clinical practice have enough common ground to be combined in the same person: research can be consistent with practice; practitioners can adopt a less alienating research orientation for the benefit of clients' (p.17).

From 1982 onwards, Payne's purpose was 'to explore DMT as experienced by the clients themselves, including their reflections on the process in some way … One comment I made at the first meeting with my academic tutor was "if it has to be measured with numbers then it is probably the wrong path for me"' (p.24). From the point of view of designing appropriate research, DMT typifies the fragile interpersonal processes which characterise the arts therapies as a whole. Payne describes it as 'action based, involving verbal and vocal exchange, but not dependent on a high level of language skills. The body and movement are the vehicle for expression and communication in a pre-verbal and symbolic manner … Symbolism, and the use of body as metaphor are fundamental to the approach. It embraces elements from dance which include rhythm, space and energy. Creative movement rather than prescribed steps is the basis of the approach, although task-orientated or developmental movement approaches are also utilised, depending upon the population … The aim is to work with the individual by means of the group itself … Using free-floating group association, in movement, sound and words, an explanation of the group's unconscious is possible where members themselves interpret the processes' (pp.42–43).

Payne's pioneering work in DMT developed from what she describes as 'a traditional research methodology', according to which she observed the effect of a short programme of movement therapy on children with behavioural difficulties. In this, apart from arranging that the children should be separated into a control and an experimental group, she herself had direct contact only with the teachers, asking them pre-arranged questions and rating their answers according to a list of standardised emotional behaviours. In other words, the investigator observed Ss' behaviour at second-hand by means of the teachers' judgements which were themselves elicited in a formal way by structured questioning. Within the limitations of this 'old paradigm' approach, however, the exercise was successful and produced the results that had been hoped for: 'Specific movement patterns were shown to correlate with particular core syndromes which, after a programme of movement therapy, changed to become less dysfunctional, illustrated by the rating scale results correlated with movement profiles' (p.19). When the experimental report was written it was not shown to the teachers involved. In this piece of

research Payne was a visiting researcher, separated by her role from the teachers themselves and certainly not in immediate contact of any kind with the actual processes of therapy. Conscious of this distancing effect, she collaborated with other members of staff in the school where she was herself working in a piece of research which extended for two years. This longer project involved the use of video as a means of recording actual therapy sessions, thus narrowing the gap between herself, the teachers and the children undergoing therapy.

Apart from this, however, the approach remained the same in the sense that neither the methodology nor the collection of data had changed. The results pointed towards a definite therapeutic outcome. At the same time, the design and methodology of the experiments prevented them from yielding useful information about the actual processes involved: 'It became obvious in this second study that I was not learning anything about how the therapy worked, nor was the research contributing much towards a body of wider knowledge about human behaviour' (1993, p.20). She passed further on, extending the scope of her research in a third project to 'explore links between body image boundary, social adjustment, self-concept and self-actualisation' (p.22) in the hope that it would reveal evidence of the suitability of DMT as a way of improving the level of self-concept among emotionally disturbed children. Correlations between the four variables were listed by computer analysis with results that 'looked impressive to the reader' but failed to convince Payne herself that she was any nearer to what was beginning to emerge as her principal aim in carrying out research into DMT. Somehow the actual process of therapy must be examined and understood, and the only way to do this was to find a way of bridging the crucial gap between researcher and practitioner. In other words, there was no substitute for a real change of research paradigm.

Because they go out of their way to avoid the inflexible procedures of quantitative research, action methods involve a high degree of personal choice as to which of the many research pathways should be followed. During the years since 1980 Payne has been involved in a succession of projects, each one of them different from the others but all concerned with various aspects of action research. Action methods try to avoid structuring experimental procedures in ways that remove them from any meaningful comparison with situations actually occurring in 'real life'. Consequently, they are more concerned with principles and guidelines for research than with actual procedures of the kind that could be used as step-by-step

instructions for carrying out experiments. Payne does not attempt to describe the stages in and components of her action research in the same way that she treats her earlier investigations. In fact, she cannot do this because the material to be considered within the new paradigm is not the product of the same kind of discrimination and selection that characterise both quantitative and qualitative research. Because the world to be investigated in action research is the real world, the world as we know it, the perceptions and experiences that turn out to be significant cannot easily be disentangled from those that are less salient. The principles that guide action research are intended to preserve a holism rather than categorise the separate components in a machine. Action research is enquiry into things that hold together in relationship rather than simply being put together for a purpose. In a sense, they can only be understood from the inside. Detachment transforms them from holism to structure, removing them from the world of experience to that of ideas – actually making them less real than they are, than we know them to be when we participate in their life.

An example of this is the difficulty Payne encountered when trying to draw conclusions about a group of people engaged in dance–movement therapy who were not always all present every time the group met, a frequent state of affairs in group therapy of all kinds. The problem is, of course, that the group continues even though its numerical strength fluctuates. Is it to be considered as continuous, in the sense of always being the same group? This is a problem which renders scientific inference, in either its quantitative or qualitative form, impossible to achieve in any practical sense – yet there is little doubt that it is part of the real world and requires investigation. 'The learning here,' says Payne (1993), 'was that naturally occurring phenomena need to be studied rather than a false picture of an all-present therapy group' (p.26). In fact, the new paradigm has less of a problem here than the old one had: by participation in the group the investigator preserves its ongoing life, the holism involves everyone concerned in a reciprocal research experience and is both the subject of the enquiries and its actual terms of reference. The real nature of this kind of transactional research is revealed by the awareness that this problem actually exists and that the kind of evidence about reality presented by keeping score of numbers cuts across the experienced fact of a continuous group identity.

Because it is about human relationship, new paradigm research focuses on personal identity. It is in the group that the individual discovers a sense of his or her own unique selfhood, as this is reflected back and validated by other

people who are present. Interactive research sets out to dispense with the autocratic experimenter-subject confrontation. 'The basic arguments put forward in favour of new paradigm methods,' says Penny Rogers, 'are that orthodox research methods are inadequate when used to study people because they undermine the self determination of their "subjects". When the subject of a study is human, it is important to recognise that she has the ability to choose how she acts and has the capacity to give meaning to her experiences and to her actions. Orthodox research methods,' she concludes, 'exclude the subject from all choice about the subject matter of the research, all consideration of the appropriate method of inquiry, and the creative thought that goes into making sense of the research' (Rogers 1993, p.203).

In an investigation into the use of music therapy with people who have been sexually abused she follows a model suggested by Reinharz (1981) (see Figure 7.1) which regards the process of enquiry as a circular path or movement involving four elements, all active contributions to the final research, and each one dependent on the other three: acting and experiencing (i.e. concentrated research activity such as data collection and fieldwork), reflecting (work carried on at one remove from the clinical interface; analysis and synthesis), integrating (relating ideas about the research to information gathered from other sources) and communication and planning (What have we found out? Where do we go next?). This cycle of experience and ideation has the effect of preserving a sense of continuity within the research process so that it does not arrive at a predetermined point and then stop but goes on widening and deepening, even after the final report has been written. In

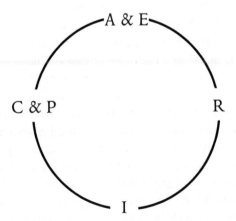

Figure 7.1 The Enquiry Process (Adapted from Reinharz 1981)

other words, it has the effect, described by Payne, of contributing towards a body of wider knowledge about human behaviour.

The model represents the attitudes and intentions of the people taking part, their mental plan of how the research activity was to be carried out. For practical purposes, of course, the project went through successive stages in its progress from idea to actuality.

Rogers describes a programme of research aimed at understanding the therapeutic processes at work in the music therapy sessions she was carrying out in a large mental health unit which had not previously had a music therapist. Her therapy group included clients of different ages, adults, adolescents and children. Before therapy could really get under way, she had to carry out a certain amount of preparatory educational work among the clinical and nursing staff ('There were a few pre-conceptions as to what music therapy entailed'.)(1993, p.202). Her research approach is briefly described in what follows.

1. The research suggestion was 'tried out' with professionally involved individuals and then with a group of other music therapists: 'a revision of the research design and a re-focusing of the aims of the enquiry resulted'. This process of re-consultation and revision continued for some time so that 'a cyclic pattern of inquiry, with meetings with other music therapists for thinking and planning, followed by periods of on-the-job research in the clinical field is seen to develop, with movement around the cycle from reflection to action and back again'. (1993, p.204)

2. Parallel with the process, the clients themselves were engaged in consulting with the therapists and one another about the research in which they were going to be taking part and their role as co-researchers into their own experience, as individuals and as a group. Rogers describes a two-stage process of therapist–client consultation in which co-operative action in the actual course of therapy is reinforced by opportunities for talking things over retrospectively, so that clients are able to say how they really felt during the sessions, liberated from the demand characteristics associated with the therapist–client relationship during actual therapy. She reports that 'not all clients agree to participate in the co-operative inquiry group whilst engaged in therapy, but for those who feel able, such participation is encouraged,' adding that 'the "power of the secret" can be a seriously inhibiting factor in involving clients in a

co-operative inquiry group, as they may not wish to discuss the very personal process of therapy with others' (1993, p.204).

3. Clients were encouraged to keep diaries of the research process (and of their experience of sessions) and questionnaires were completed by them after each therapy session. These were kept separate from the therapy sessions themselves. They were not seen by the therapist unless clients actually included them in the group sessions. They were used as a source of information about clients' experience of therapy which could be expected to be less influenced by the implications and expectations of the traditional client–therapist relationship, serving as an outlet for feelings which might not be publicly expressed.

4. Rogers tested the following elements within the overall research design – analysis of audio-visual records of therapeutic sessions; analysis of clients' diary records of sessions; analysis of questionnaires completed by (a) clients themselves, (b) clinical staff (apart from the therapist, who did not actually see these until the therapy sessions had been completed); analysis of therapists' own diary of the sessions; consultation with a 'co-operative enquiry group' comprising of clinical staff involved in the care of the clients while they were in the hospital unit and ex-clients of the unit who had volunteered to act in this capacity; consultation with a second 'co-operative enquiry group' consisting of professionally qualified music therapists whose job was to monitor research procedures.

This wide-ranging strategy includes a range of opportunities for gaining information about the overall therapeutic effect of the use of music therapy with psychiatric patients in a clinical setting and, at the same time, allows attention to be directed towards more specific questions, one of which would almost certainly concern individual clients' perceptions of themselves in the very different roles of a member of a therapy group in a mental unit and the writer of a personal diary. Rogers analysed her data from two main points of view, using both individual case studies and comparisons between subjects together. These two approaches to the gathered data build up the kind of picture aimed at by action research. There is no intention here of producing the kind of 'experimental result' required from quantitative or even qualitative research, when the latter abides by the principles of scientific inference. No claims are made here about the generalisability of results or the repeatable nature of causal effects. This certainly does not mean that the

investigation provides no evidence in support of this kind of claim if it were to be made. It only means that the researchers have preferred depth and richness of description to a precision which is certain to militate against either and may actually distort what it is attempting to distinguish. There is very little doubt that the picture of music therapy which emerges from Rogers' study is of much greater value to other therapists than the experimental isolation of a particular effect or effects would be. If understanding and confidence on the part of therapists is a value of concern to those responsible for monitoring research, this kind of action investigation deserves the kind of 'official' support and encouragement given to conventional research designs.

Reading List

Reason, P. (1988) *Human Inquiry in Action.* London: Sage.

Reason, P. and Rowan, J. (eds) (1981) *Human Inquiry: A Sourcebook of New Paradigm Research.* Chichester: Wiley.

Practitioner Research

Even this degree of systematisation is unattractive to many arts therapists. In 1990, at the Second Arts Therapies Research Conference which was held in London at the City University, David Edwards asked the crucial question: 'Why don't arts therapists do research?' At the heart of his paper lies this perception: 'The bodies of knowledge upon which the arts therapies professions are based are often at odds with the value systems which currently dominate our culture and its institutions' (Edwards 1993, p.11). Edwards is himself a leading British art therapist. What he says calls forth a positive response from a large number of other members of his profession, all of whom believe that the effectiveness of their therapeutic practice does not need to be demonstrated in terms of systematic research, whether quantitative, qualitative or action based. Edwards himself acknowledges the need to convince non-arts therapists about the crucial role to be played in psychotherapy (using the term in its broader sense) by these kinds of therapy. Nevertheless, he is firmly convinced that there is a very real danger that attempts to do this by means of experimental procedures are, at best, unconvincing (and perceived as such by the people they set out to convince) and, at worst, counter-productive and positively harmful to therapy itself. I have come to the conclusion that although a realistic response to the pressure placed upon arts therapists to demonstrate the effectiveness of our work might well be to adopt and use what we can from traditional research methodology, I personally doubt whether doing so will, in the long term, prove very helpful in furthering our understanding of the meaning and value of the relationships we have with our patients or clients. It is my view that prior to the question 'Does art therapy work?' is the more pressing and clinically relevant question: 'What factors determine whether a relationship is traumatic or healing?'

As we have seen, arts therapies research appears to reach the same conclusion itself. Valente and Fontana (1993) and Grainger (1995) point out

that dramatherapists rate relational values higher than technique or expertise as indicators of therapeutic success. As is the case with other enquiries of this kind, however, their efforts are aimed at identifying factors or elements within 'the therapeutic relationship' which are particularly effective in producing healing in dysfunctional people. It is this frame of mind that is being criticised and rejected here. Considering art therapy itself, Edwards (1989) points to a holism – personal relationship – mediated not by explanations or interpretations but by the only thing that is capable of mediating it, the imagery of another holism – art. As it is the personal relationship established between the therapist and the patient – a relationship mediated through images – that is central to art therapy, it is essential that the subjective experience of the relationship from the perspective of both the therapist and the patient be taken account of in any process of evaluation. Edwards stresses that it is not rational and systematic investigation which he is arguing against but a particular approach to such investigation – namely, the experimental or experimentally conceived and organised approach. The first takes account of the fact that there may be things about life which defy reduction to their constituent parts. The second does not.

Unfortunately for research purposes, it is precisely these things – the ones which defy reduction – that arts therapies are primarily concerned with. The arts therapies do not use art as if it were some kind of tool; in their essential identity they *are* art, functioning the way art functions. Because their aim is to understand an experience in its own terms rather than to try to translate it into some kind of language foreign to itself, 'interpretations of what is actually happening in therapy are more like aesthetic judgements than scientific judgements' (Grainger 1990, p.101; see Cheshire 1975, pp.86–88). Arts therapists tend to evaluate their different approaches in their own terms – that is, in terms of the artistic event and their own involvement in it. In Eisner's words, they 'let the problem determine the method, not vice versa' (1985, p.136). For instance, a dramatherapist who is trying to find out whether a session of dramatherapy is genuinely therapeutic asks questions about the extent to which a group is succeeding in creating its own shared imaginative 'world'; the degree of awareness that those taking part have of the difference between this and the 'world outside'; the risks that participants are taking in allowing themselves to 'play' in this kind of way and to assume other people's roles; their difficulties in coming back to ordinary reality again. In their own ways each of the arts therapies inhabits an artistic

environment of its own and judges success or failure mainly in terms of this particular context. This kind of assessment, on which the therapist's personal belief in the therapeutic value of her or his work rests, cannot be carried out unless he or she is able to share this world too. Eliot Eisner (1985) described a similar kind of involvement on the part of teachers who try to gauge the quality of learning taking place within a particular classroom context. He too warns of the effect of being regarded as a detached observer by the people whose experience you are trying to understand: 'The tests we use are not simply neutral entities, but have distinctive effects on the quality of our perception and upon our understanding' (p.114). Taken by itself, of course, this kind of imaginative evaluation is only one element in a qualitative research design, one of the many approaches that together make up a comprehensive research strategy, in which personal judgements, intuitive or otherwise, are measured against one another. There seems to be good reason, however, to regard it as the active ingredient in our understanding of how the arts therapies actually work.

Aesthetic Criticism

Using Eisner's educational objectives (1981) and Abbs' model for the aesthetic field (1987) (in which aesthetic knowledge is seen as a category of understanding for the creation of meaning, not through intellectual analysis, but through the engaged sensibility of the perceptive, affective and cognitive faculties), data collected through observations, questionnaires and tape recordings of interviews and sessions were assessed in relation to outcomes within the 'education–*in*–dance–movement' and 'education–*through*–dance–movement' curriculum approaches. An ethnographic methodology (Nesbit, 1976) was used to illustrate the varied and rich life of the classroom, of the interactions between dance and movement and the child, between teacher and child, and between the groups. In this method the researcher gathers objective and subjective data from a variety of sources. The researcher then exercises personal judgement in deciding what is important in the data collected to illustrate the educational experience. This method also takes into account the social structure and emotional climate in education of these pupils. The need to have some criteria for giving these personal judgements something other than private and perhaps idiosyncratic value, led to the use of the educational researcher as 'art critic' approach (Eisner, 1981; Ross, 1981). The judgements expressed by the researcher

as 'art critic' must be capable of reasoned justification and take into account the values and personal needs of the children. Both ethnographic and art critic approaches to methodology are compatible with the view adopted of dance and movement as aesthetic experiences. Outcomes were evaluated in terms of curriculum areas and dance–movement forms.

(R. Scott 'An investigation into the outcome of dance and movement in the curriculum of children with emotional and behavioural difficulties.' In Kersner 1990, p.70)

To be true to our various media we have to find a place for this kind of aesthetic criticism in our research. In practical terms this will mean contriving ways of recording sessions which are able to do more than observe the behaviour of those taking part in as technical – that is, as dispassionate – a way as possible. Personal assessment carried out by researchers and researched (and by those fulfilling both these roles), involving imaginative description and the artistic use of video, must play a crucial part in the evidence on which judgements about success and failure are to be based. No doubt traditional researchers will continue to regard this kind of 'subjective' material with suspicion. Arts therapists, however, will themselves always be suspicious of attempts to reduce the artistic event to something other than itself.

This being the case, action research, founded on a 'new paradigm' of what it is that research into the human situation should be and do, is likely to commend itself to some arts therapists as the only tolerable kind of investigative approach. The argument would be that in this kind of enquiry the specific research elements, those characteristics of structure directed at asking precise questions and drawing firm conclusions, can somehow be played down or actually used to form a protected environment for genuine personal relationships to happen in – an idea likely to commend itself to those actively involved in any therapy in which art is consciously used as a medium for encounter (Grainger 1995; Jennings 1990, 1992; Jones 1995; Mitchell 1996). This being the case, however, particular care has to be taken that the 'protected space' is allowed to keep its unique identity without being corrupted by the impersonality of the investigative process. In other words, it must be a space for people and not merely a source of evidence. Much of the technical skill of arts therapists is directed towards contriving a kind of absence, which is very different from the intrusive presence often associated with 'scientific enquiry'. In other words, the structures of arts therapies are

not the ones envisaged by orthodox science and do little if anything to resolve the tension that exists between what administrators and paymasters want and what therapists and artists know to be appropriate.

This, of course, is the situation to which I drew attention at the beginning of this book. I pointed out then that it is a widespread problem affecting research into our understanding of social relationships and, consequently, has a very direct relevance for any attempts to clarify our understanding of the arts therapies. It is important to realise, however, that it is a problem about attitudes towards research, not about research itself. More precisely, it concerns the ways in which research is defined. The three ways of looking at research which we have been concerned with represent three distinct attitudes towards measurement. Quantitative research sets the highest store by numerical accuracy: successful research is regarded as precisely measuring data. Qualitative research is also based upon measurement, the difference being not the theoretical status of measurement itself but the ways in which it is carried out. Only new paradigm action research relegates measurement to a secondary role, preferring other ways of arriving at the understanding of relational phenomena. As King, Keohane and Verba (1994) point out, qualitative approaches may still 'keep the rules of scientific assessment'. The logic of qualitative research need not differ from that of quantitative design. They convincingly argue the mathematical properties of using qualitative research in areas where numerical measurement is either impossible or undesirable. Neither quantitative nor qualitative measurement is the principal aim of new paradigm action research, concentrating as it does on the examination of situations as they are in themselves rather than in terms of their comparable status. Because it is mainly concerned with investigating and exploring process, the latter approach usually limits itself to the study of only a few cases – those that go together to make up a particular interpersonal situation, in fact. Statistical procedures work more efficiently when the number of observations is large than they do when they are small because the random selection of cases and their assignment to experimental and control conditions is necessary to produce the kind of representativeness on which statistical testing depends. What King and his associates call 'the fundamental problem of causal inference' – in other words, having to compare a case in which something happens with a hypothetical identical one in which nothing happens in order to isolate the causes of a difference between them – means that special precautions have to be taken to preserve the efficiency of 'low n' designs which conform to the pattern of quantitative

research. If the uniqueness of an interpersonal situation is to be preserved under such circumstances, examples must be specially selected to cover the range of ways in which a particular kind of behaviour or personal experience is recognised as occurring, so that the maximum amount of data may be obtained from the comparatively small number of subjects involved in the investigation. In this way even interpersonal processes may be studied without parting company with the traditional paradigm of scientific research – if that is considered necessary.

At the time of writing, most of those interested in carrying out research in the sphere of the arts therapies are what Colin Robson (1993) has called 'practitioner–researchers'. The subject area is not well enough established to be attractive to research of a purely academic kind, the kind carried out by people who are more interested in the process of research than the reality of the situation they are researching. A practitioner–researcher is 'someone who holds down a job in some particular area and at the same time carries out systematic inquiry which is of relevance to the job' (p.446). Most arts therapies research is the work of people actually engaged in practising one or other of the arts therapies or preparing to do so. Such people may be expected to be genuinely interested in, or even committed to, their subject but restricted in the resources they can lay their hands on, unless, of course, they can find a university department willing to accept it as an appropriate material for a research degree. Actual sponsorship is likely to have definite conditions attached to it – money will only be forthcoming so long as exactly the right kinds of goods are supplied! This is not to say that the kind of agreement acceptable to both sides may not sometimes be negotiated – there have been several examples of successful partnerships between individual researchers and sponsoring institutions in the field of arts therapies research – but there is always the implication that a researcher is being retained to produce the kind of results the sponsor wishes to receive. In fact, of course, the suggestion that definite results of any kind are required feels like a restriction of freedom to those about to set out on the long and difficult journey represented by any piece of authentic research.

Practitioner–research highlights this particular problem in that it is often undertaken under the auspices of, or with the actual blessing of, the organisation by which the potential researcher is employed. It is extremely hard to see how the business of carrying out a research project could really be detached from one's employer's business, particularly if the intention were to use the organisation's clients or one's fellow employees or both as subjects for

study. Yet this is the situation with which many researchers are faced nowadays.

Like many professions, the arts therapies originated in the discovery that something actually worked: the arts really could contribute to psychological healing. As in all such cases, practice ran ahead of theory, leaving the latter with a good deal of room to make up. Arts therapists are fascinated by the prospect of finding out more about how their approaches function, what actually makes them heal people. Administrators faced with the necessity to provide therapeutic services are fascinated by the possibility of discovering cheaper and more effective ways of doing so. The two forces have combined to produce a new role, that of 'arts therapist practitioner–researcher'.

Its origins are really quite straightforward. Arts therapists, enthusiastic on behalf of approaches that they are convinced constitute a unique contribution to healing, have to survive in a world where the only arguments that carry weight are those that use the language of science. For them, the road to acceptance as a genuine psychological therapy must pass through research. The current stress within the NHS on 'evidence-based practice' – according to which practitioners are encouraged to substantiate their work by referring to relevant research – means that there is an increasing amount of pressure on therapists of all kinds to find ways of evaluating their methods which will carry weight in an aggressively scientific culture. Similarly, health administrators must reassure more theoretically developed branches of healing that this new approach is not simply a kind of applied folk medicine – they too are eager to see research carried out within the arts therapies sphere. Both sides agree that the obvious people to do this are the arts therapists themselves. The only thing to be decided, then, is what kind of research it should be. More precisely, what kinds of activity on the part of arts therapists would be considered to constitute valid research projects?

We have already looked at what arts therapy research should not be. It should not be a ragbag of ideas, attitudes and experimentation thrown together on the refuse bin principle in the hope that greater understanding of some kind of underlying therapeutic process may emerge. Neither should it be the inappropriate use of measuring instruments never designed for recording information about human relationships, resulting in the distortion of the material it seeks to understand. If we want to examine a particular event involving human beings, we may not simply contrive ways of disregarding the rest of the picture, we have to attend to the living context

and notice how it illuminates whatever it may be that we are trying to understand. Physicians do not anaesthetise bodies to see how they work!

Arts therapies research must be real research into conditions obtaining in the real world. Robson (1993) speaks of 'study relevant to the professional setting, in part at least determined by the agenda and concerns of that setting'. He points out that in practitioner–research 'reduction in individual freedom is balanced by an increasing likelihood of implementation, and of additional resources and time' (p.446). This is real research as distinct from an academic exercise, its reality demonstrated by the two most important things about it: the enthusiasm and personal involvement of the people carrying it out and the economic circumstances giving rise to it in the first place – it must be real to continue in existence! Practitioners who are researchers have a sense of focusing on a particular aspect of their own lives, of themselves even, which makes the project personal in a way that distinguishes it from traditional academic research. Once under way, this kind of investigation stands a good chance of being completed, if only because of the degree and kind of investment made in it by the researchers themselves, who already know more about their subject than any outsider and are highly motivated to discover even more.

This, of course, is in complete contrast to the state of affairs traditionally associated with academic research, where those carrying out an investigation are required to maintain a degree of emotional detachment from the task in hand so that their intellectual acuity may suffer as little as possible from any personal prejudices they may have. The kind of experiment associated with quantitative research is designed in accordance with a way of thinking about human enquiry which maintains that it is possible for human beings to perceive the world as if they are somehow absent from the reality they are concerned with. If this is so, the best way of countering personal bias is obviously to urge researchers to remain as detached and impersonal as possible. The growth of qualitative research may be seen as corresponding to the emergence of an alternative view of the epistemological relationship between subject and object, one which states that this kind of distinction cannot, in fact, be made with anything approaching accuracy and that the attempt to be accurate about it actually detracts from the realism of what we are perceiving. Qualitative research aims at producing a picture which, although it may be less clearly defined, is also freer from the presence of distortion; a result which is more likely to be true to life rather than a striking oversimplification which may quite possibly be a dangerous misappre-

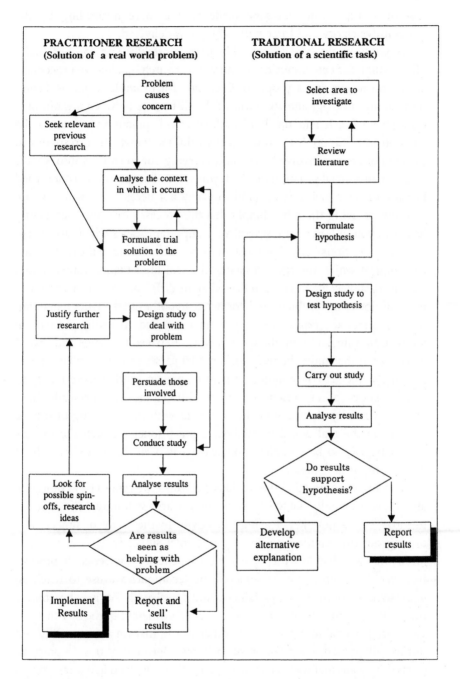

Figure 8.1
From Robson (1993)

hension – the wrong message made all the more misleading by the pre-emptive clarity and force with which it is delivered.

Thus it turns out to be considerably more painstaking and rigorous than is often assumed. Seen alongside quantitative research, qualitative procedures are by no means an easy option. Compare, for example, Colin Robson's presentation in diagrammatic form of the difference between a traditional research approach and the kind of 'real-world' practitioner–research he advocates (see Figure 8.1). In the 'real-world' model which corresponds to the kind of process involved in actually carrying out an enquiry into what is going on in a social situation in which you yourself are personally concerned because of your own interest (and this may not necessarily mean you are working or living there but simply that the process of enquiry necessarily 'includes you in'), there are several very important stages which are absent from the 'traditional' one. The most important one is actually the first of all – the point at which the research starts in a real life situation rather than a contrived 'subject area'. This is reflected in the difference between 'formulate trial solution to the problem' and 'formulate hypothesis', the latter remaining in the abstract at a point where the former is already thinking in practical terms about things that might actually work. Between this stage and that of carrying out the study, the real-world model passes through a phase that is absolutely crucial to the enquiry, both from a practical and a theoretical point of view, yet is entirely absent from the traditional model – 'persuade those involved!' Finally, the traditional model ends with the reporting of results, whereas in the real world of qualitative practitioner research the process cannot be said to be complete until what has been discovered is utilised within the social context.

By acknowledging that the world is our world, we cannot be as objective about it as we would like to be. We permit research within real-life contexts to move into a new key, leaving objectivity to the study of objects and turning our full attention to investigating inter-subjectivity. This does not mean that we abandon the systematic elements of the research process, however. We simply change some of the techniques we use to reach an understanding of the state of affairs we find ourselves in. For instance, one of the things we must do to counteract the effects inherent in the fact that our views are personal to ourselves – in other words, that we are invariably and intrinsically biased – is make proper acknowledgement of this. In practical terms this means that we need as many researchers involved in our research as possible in order to register and demonstrate the factual nature of the

differences of individual perception involved in participant observation – the only authentically human experience of reality. This does not make the conclusions we draw from the evidence less scientific but merely less simple.

What would make them less scientific is any departure from the rules governing inference. Science calls on the logic of descriptive and causal inference in order to carry out its investigation of phenomena – any kind of research which conforms to this is authentically, inalienably scientific. Science, when it comes down to it, is principally concerned with the establishment of evidence. A basic definition of it would be the action of distinguishing what is evidence from whatever is not. Accounts of states of affairs are scientific to the extent that they are not fictional. This means that the notion of something's being 'scientific' does not need to be – indeed, cannot be – pre-emptive. Human knowledge and understanding being what they are, all science contains fictional elements. Scientific inference is a technique for distinguishing intended fact from outright fiction. This being so, those who require truth from research must be willing to take the will for the deed, for what we call 'scientific objectivity' refers as much to intention as execution.

People engaged in research, however, must still make every effort to convince the world in general, and their paymasters in particular, that they have made all the efforts to distinguish fact from fiction that are possible to make. Sometimes this can be done by generalising from cases that are observed to those that are beyond observation, sometimes by the sheer accumulation of relevant instances. Practitioner–research, because it is concerned with the researchers' ongoing occupations and interests, tends to pay attention to process – that is, to adopt a qualitative approach – so that it is particularly important to bear in mind that any sponsors are primarily interested in the outcome of approaches being investigated. As I have said earlier, in order to carry the kind of weight traditionally accorded to quantitative studies, qualitative research has to cover a wider canvas and produce a greater range and variety of evidence (Maxwell 1996; Robson 1993). In practical terms this means making more pre-investigative contacts, preferably ones you may be able to include in your actual research; negotiating plenty of time in which to carry out your project, write it up and communicate your results to as many interested parties as possible; working with other people in a research team rather than trying to go it alone; laying on adequate clerical or secretarial help; consulting with other people who

have been involved in designing and carrying out qualitative research from a practitioner–researcher standpoint.

It should always be remembered that the need for evidence comes from two directions. Certainly, to satisfy your sponsor your research must be systematic and painstaking. For you, however, it must be even more than this. Because you are looking into something which concerns you in a life-affecting way as part of your daily experience, you will not be satisfied until the way you are carrying out the project corresponds to the impulse that led you towards it in the first place. In other words, your work must 'feel right' to you and you need room to manoeuvre until you recognise what it is in your subject that you really want to find out about and what it is in you that wants to find it. In personally motivated research these things are not always immediately apparent. Making them clear enough to be studied is an organic part of the investigation. Indeed, it is the crucial part. The clarity of a piece of research belongs to the research mechanism itself and the skill with which it is used. Its usefulness, however, has more to do with the sensitivity and honesty of those who have involved themselves in it.

Qualitative research, rooted in the experience and interests of those carrying it out, should never be regarded as a failed attempt at traditional research. Its comparative messiness and lack of quantitative underpinning should not be automatically considered proof that it is in some way methodologically suspect. As Robson (1993) reminds us: 'The real world investigator's responsibilities often extend further than is expected in the traditional model' (p.453). This is research that is inherently practical, proceeding from actual work situations that call out to be understood as well as they possibly can be if they are to play the part they should in carrying out the aims of a sponsoring organisation or institution. No such authority can afford to use research simply to test the outcome of particular work strategies without exploring the interacting behaviours involved in producing these outcomes. Faced with a choice between quantitative research based upon the measurement of particular changes and qualitative research directed at illuminating the processes involved in bringing about situations of change within a particular context, those whose job it is to provide research funding and facilities should bear in mind the advantages of the latter in terms of the amount of useful information to be gained – including information about the effectiveness of techniques, which can be all the more valuable for not trying to make exclusive claims within the sphere of causality. After all, there is not really very much point in knowing precisely what happens in circumstances

which can never be reproduced by those in the position of having to 'do the job'. The history of academic research clearly shows how frequently exactly right solutions have been shown to be completely wrong – and research that has been convincingly discredited is good for nothing save to be written off for tax purposes!

On Persuading Those Involved

Letting people know exactly what you have in mind is always exceedingly important. I have fallen into the trap of delaying this vital stage on several occasions when I have been considering carrying out research of various kinds, and it is always fatal. It has to be done properly, and it has to be done early on in the proceedings, because once things have even begun to get under way it can be quite literally too late to go back. The study is ruined, and the people you are interested in finding out about are permanently alienated. (This is quite true, believe me. I've had them complain to the management and that was when it wasn't even they who were being studied!) They don't mind you going about your own business as a researcher, but not here, not now, and certainly not with them. In the old days of psychological research, of course, the whole point of the thing was to keep people in the dark. That was all right, though never very ethical, you simply kept your own counsel and beavered away behind people's backs. Nowadays, however, the situation is quite different. Your research is part of your ongoing work in the department, on the ward or in the classroom. It's the department, ward or classroom that you're researching. Everyone knows this, and they all want to know everything about it because in some way or another they themselves are going to be affected by your research, so you can't really blame them. These people have got to be built into whatever it is you're doing, not merely to placate them and render them less suspicious, not even because you really need their expertise (although you'd be surprised how often that comes in useful), but because they're there and that's the way it is. That's the reality situation.

(A music therapist – personal communication)

Art-Based Research

> There is no single and authoritative way to relate to a work of art or to the intricacies of artmaking, which are even more elusive. (McNiff 1998, p.47)

Some arts therapists would say that none of the approaches I have been looking at are equal to the task of carrying out research into the arts therapies. This is because they are all strategies whereby an essentially creative process is looked at from the outside. Things seen in this way are never really understood properly; to begin to know them as they are, they must be looked at from the inside. In other words, they must be penetrated and experienced. This, certainly, is the main aim of the kind of practitioner research described in Chapter 8, in which the business of carrying out an investigation is shared by all taking part and researchers are committed to 'coming clean' about all their activities and intentions, abandoning their detached position as scientific observers by allowing their own experiences and attitudes to be part of the overall experimental data.

There is a sense, however, in which even this is not enough. To share an experience with others in the fullest sense, one must be able to communicate with them in the way that they themselves communicate. How can one belong properly in any community accustomed to making sense of things in a way that is completely different from ourselves? Or rather, how can we do this without speaking their language? The implications for arts therapies research are obvious: just as it takes an engineer to understand engineering, or an accountant to handle finance, so the only authentic arts therapy research is that carried out by artists. Art should be used to interpret art.

Certainly, artists who examine their own and other people's artistic productions do so as artists rather than as scientists of any kind, even psychologists. Shaun McNiff (1998), an art therapist himself, describes a kind of art-based research that is designed to produce results in the form of art rather than translating them into the language of experimental

psychology. The aim is to 'keep the arts as primary modes of psychological enquiry'. He points out that 'The images and process of artistic creation are always at least one step ahead of the reflecting mind' and resist our attempts to imprison them in the ready-made constructions we use to understand the world in 'scientific' terms 'establishing what we plan to do before we do it' (p.27). Some of the most crucial things about human experience defy analysis. Questions about the meaning and purpose of our relationship with ourselves, each other and the world are ignored by scientific studies of behaviour because of an implicit recognition of the futility of looking to science for answers. In order to receive any kind of convincing answers, these are questions which require a response that is experiential rather than abstract. To put this another way, we may draw conclusions about how things function by looking at them in as objective a way as we can devise but the 'whys' of life and death belong within the sphere of philosophy, religion and art, all of which depend on self-awareness to have any value at all. Because the experimenter is always an element in the overall experimental context, her or his personal view of the world cannot avoid having an effect upon the outcome of the investigation, if only because it determines any views he or she may have about what an experiment actually is – the kind of thing they should be trying to find out, what ought to be considered evidence of success or failure and the most effective and appropriate procedures to be adopted. Approaches that aim at objectivity by isolating the behaviour or experience to be investigated from that of the investigator may produce trustworthy information about what will happen in situations where such conditions operate. What they will not do, however, is give anything like a true account of what happens in situations where those conditions do not operate – in other words, anywhere else in the world apart from a scientific experiment. If, on the other hand, what is being investigated involves whole people instead of artificially separated parts of human situations, the inevitable participation of those carrying it out will be an asset not a handicap.

Shaun McNiff describes a 'heuristic' or empathetic approach to participant research which is founded upon the researcher's own experience of the context he or she is investigating: 'Heuristic research encourages the telling of your personal story.' Only in this way can we really engage with the human interpersonal experience we are trying to understand. He comments: 'The subjective approach, once considered inimical to research, becomes a primary feature of heuristic enquiry' (1998, p.53). The purpose is the same as

that for other kinds of research – to be accurate and relevant, a way of reporting that preserves the authenticity of the phenomenon concerned. After all, the most trustworthy information about human contexts is at our immediate disposal in the form of our own living experience of personal relationship. 'Betweenness' cannot be gauged by refusing to become involved. In trying to understand any kind of human experience, our involvement must constitute a primary source of data.

All this has great relevance for people concerned with, and involved in, the arts therapies who look towards art as a context for kinds of healing that lie outside the scope of clinical techniques and yet – as McNiff points out – often seem determined to deskill themselves by disowning anything that resists immediate translation into the language of science, however distorting this may be of the kind of insights that can only really be assimilated in the experiential imagery of art. McNiff writes powerfully and convincingly about the dangers for this kind of failure of artistic nerve: 'I urge the creative arts therapy profession to return to the studio, realising that it is the natural place for artistic enquiry and expression. All my research and experimentation with the creative arts therapy experience affirms that we must be able to "trust the process" and allow it to do its work of transformation' (1998, p.37). McNiff locates the healing action of art therapy precisely here – in its 'modes of creative transformation'. He describes the work of Ellen Levine, who regards her research into the art therapy process in the light of the Jewish tradition 'the repair of the world' (*tikkum ha'olam*), which works in order to bring healing to whatever is wounded or broken by restoring not simply individuals but contexts, ways of living – worlds, in fact. The function of arts therapies of all kinds is to create healing environments which will themselves work towards the healing of the environment.

The point is that they will work not so much instrumentally as creatively. Healing is seen not as something produced but something that *emerges*. From this point of view, the arts therapies are inherently research orientated, and we do not need to think in terms of 'carrying out research into' them but of allowing them to perform the kinds of research that belong to their own essential nature so that we can benefit from the kinds of truth they are designed to communicate. In other words, learning to speak their unique language.

From this point of view, the healing function of the arts therapies is to create contexts for existential change, the content of which cannot be legislated for or even accurately described in advance. An artistic medium

becomes a kind of laboratory for working on, and working through, alternative ways of being in the world. Art is used to fashion therapeutic space, a special privileged place and time in which we are given (or allowed to give ourselves) permission to look at ourselves, at the way we experience life and the arrangements we make for living it in a more profound and honest way than we could do outside these special circumstances – in which the use of image and symbol permits us to be explicit with and about ourselves to a degree we would not normally contemplate. Such space has to be specially created. The arts therapies use the creative imagination – the principle of 'as if' – to bring into consciousness and embody existential life changes which are taking place at a deeper, more profound level of psychic life (Jennings 1990).

Freud describes how vital psychological adjustments which involve the acceptance of powerful realities are struggled with at an unconscious level until they can be brought into some kind of bearable relationship with our conscious awareness. The best-known example of this kind of painful process of psychological change is his notion of 'grief work' (1917). It is this kind of readjustment that the arts therapy environment tries to allow and contain – to *allow* because of art's ability to *contain* powerful and disruptive feelings in a way that disarms the urge to deny their presence.[1]

Some writers on this subject (e.g. Duggan and Grainger 1997; Grainger 1990; Jennings 1990) have compared the arts therapy process to a rite of passage, drawing attention to the creative chaos at the rite's centre by means of which an existing psychosocial context is effectively destroyed so that a new and as yet unknown world of personal and social experience may come into being. McNiff sees this happening in practitioner-research, where everyone concerned in a project is caught up in an experience of painful confusion and disorientation that is in no way optional and on which any change of a genuinely creative outcome depends: 'If we become personally involved in art based research we experience how the deeper transformations of creation often involve a shamanic or Dionysian dismembering of the way we view ourselves and our existence' (1998, p.76).

1 Sue Jennings' developmental model, (EMBODIMENT→ PROJECTION→ ROLE) describes a similar process of growth–through–engagement. It has been tested across a broad range of populations involving children and adults, and is attractive to practitioners because of its simplicity and accuracy (Jennings 1990, 1998, 1999).

Researching with 'The Frogs'

Shaun McNiff draws attention to the Dionysian character of art-based research. In this section I describe the experience of a group of students I was working with who, attracted by the plot and settings of Aristophanes' masterpiece, decided to explore the play in the hope of eventually being able to stage it as theatre. I have included this account as an example of a research experience that is genuinely art based, using a theatrical approach to create a healing environment. For those of us involved in *The Frogs*, 'immersion in the creative process became a fundamental condition of art based research' (McNiff 1998, p.77).

The plot of the play is as follows: Dionysus (god of wine, rebirth and drama), convinced that the only way to bring peace and prosperity back to Athens after its shattering naval defeat at the hands of the Spartans is to hand things over to a real poet, sets out to the World of the Dead in order to try to persuade the dramatist Euripides to return and set things right. He is accompanied on his journey by his faithful slave, his ex-shipmate Xanthius. Somehow, after a series of hilarious adventures, they manage to reach Hades, only to find that Aeschylus, the senior Greek tragedian, considers that he has a better claim to be invited back than Euripides. Having agreed to abide by Dionysus' judgement, the two dramatists argue their cases before the god of drama and rebirth, the Chorus commenting on the action for the sake of the audience. (In our production this role was taken by Xanthius, who does not normally appear in this scene.) Finally, much to everybody's surprise and Euripides' despair, Dionysus chooses Aeschylus.

The play divides neatly into two parts: the first half, the journey to Hades, is farce and the second, the debate in Hades, a more serious kind of comedy – although this part, too, has its moments of hilarity, especially in our version, where Xanthius acted as clown in order to offset the earnestness of the two poets and, paradoxically, draw attention to the real importance of the ideas they were trying to put over. One of the reasons why we chose it is that we could play about with it without destroying it – a genuine transitional object! Of the seven performers, four had never acted before and were apprehensive about launching into something too serious. We wanted a play that we could alter to suit ourselves. We chose the right one because it turned out that most, if not all, the changes we introduced added to the spirit of the play and made its purpose clearer without distorting it. There were some things we did because the actors concerned liked doing them – whenever this enjoyment was communicated to the audience, they laughed too, albeit sometimes in a

rather puzzled way, urging the actor to make his or her intention clearer. This is not recommended as acceptable theatre but simply recorded as something that happened to us in *The Frogs*.

In the beginning there had not been any real intention of performing the play for an audience. We read it and laughed at it and worked out modern parallels for the references Aristophanes makes to people he wanted to poke fun at. As we started to perform our own version of the kind of thing the playwright had in mind, we found we had actually got parts of a play and then, finally, a whole play! Of a sort, that is. I don't remember at what point we finally decided to put it on. We kept changing it and changing it until the play had developed within the group of us the *esprit de corps* necessary for its performance.

There was the general view that the play itself goaded us into performance. More than this, it actually made us into a theatre company. Technically speaking, we hadn't much going for us. Not only were there too few of us, but an age gap of thirty-five years separated the four younger members from the two oldest ones, the seventh being stuck somewhere in the middle. It was not any kind of formal group brought together for purposes of therapy or training. The younger people were studying classics in the sixth form and were enthusiastic about Aristophanes, the rest of us simply liked plays.

As time went on, however, and the group started to be aware of itself as a team of actors at work on a play, the state of affairs within people's personal experience – their private lives, in fact – began to express itself in terms of the play we were doing. Age differences stopped being something which, in our determination to work amicably together, we were trying to ignore but rather became features of the group which we were keen to exploit for dramatic effect. At first we thought it might take away from Aeschylus' *gravitas* to have him played by a seventeen-year-old – how would he stand up to an Euripides already in his mid-fifties? In fact, however, the reverse happened, the young man playing Aeschylus was able to draw on a vivid perception based on current personal experience of just how authority looks and sounds – he went straight to the heart of Aristophanes' intention, leaving Euripides grumbling and complaining like an angry teenager. The patronising comments of the Chorus gained a strange authority and force by being translated into the pathetic dignity of a clown. Dionysus himself, at least twenty years overage, embodied the desperate, swaggering mixture of con-man and *roué* that most of his lines would have us believe him to be, so

that the final demonstration of his poetic intuition and godlike wisdom was the delightful surprise the author had in mind.

There was more to all this, however, than a series of artistic obstacles ingeniously overcome – certainly much more than a small group of actors who had found themselves in the wrong play and were desperately making the best of a bad job. It was these difficulties, these problems, that bound us together in our common effort to make what we could of what we had. More than this, we had managed to do even better because, in some cases, our novel approach might definitely be said to have actually reinforced the play's message. At least it could be said by us, and saying it gave us an immense amount of satisfaction. The differences among us were real and did not only exist within the play. At the centre of the group's self-awareness a tension existed which was to grow as rehearsals continued until every member of the cast had been caught up in the anxiety to which it gave rise. This need not be described here, except to say that it involved a conflict of loyalties amongst the younger actors which gave rise to a degree of passion that in other circumstances would almost certainly have torn the group apart. Only the play kept us together, by giving us a purpose that we all shared – and, of course, a safe place to 'let off steam' and to experiment with relatedness under cover of role. During rehearsals there was too much to do for us to spend time examining these things, or even really mention them much. We were intensely aware of their presence, however. More than this, we were also aware of one another's awareness. It was afterwards that the sharing came and, with it, the ability to understand and be healed by what had happened to us in the play.

There is no doubt that the play itself – being in a play, finding the strength to face an audience – seemed to us to be an achievement. We were left asking one another how we had managed to pull it off. Nobody had been confident – even the director, who had never had such a raw cast to work with and was extremely conscious of the radical approach to casting and presentation. In fact, these were the things that made the play 'work' – the freshness and nervousness of the cast and their vivid awareness of the play as a piece of theatre and, of course, the play itself. There were certain things about *The Frogs* that made it just right for us.

Some of these things were technical and involved the conscious effort to develop new skills and the frame of mind to go with them. The style of writing in the first half of the play suggests a way of performing which resembles pantomime – the audience are confronted with a stage 'world'

whose effectiveness actually depends on its not being taken too seriously, either by itself or by the audience. For example, the actors step out of role in order to make comments about other actors' performances and personal characteristics, just as if they themselves were members of the audience. Their ability to do this without destroying the theatrical illusion is indicative of the kind of illusion it is – scarcely an illusion at all, more a free-wheeling arrangement between actors and audience to revisit a story, and a frame of mind that they all know well and enjoy very much. Identification takes place, certainly, but it is an interior recognition rather than the conscious and intentional 'suspension of disbelief' that other kinds of theatre require. Too much belief in this case would only have the effect of leaving the audience frustrated and puzzled. Instead, they enjoy the experience of sharing an old story as a story – something which, after all, is only enjoyable because it isn't actually, in the ordinary, everyday sense, true at all. By the time the mood and intention of the play changes, the degree of imaginative involvement for both audience and actors has increased and we are led deeper into the happening, sustained, even in Hades, by the quality of the friendship which developed among us in the first act.

All this suited us down to the ground because it meant that we were not solely dependent on an ability to act, in the ordinary sense of the word. Our job in this final part of the play was simply to carry out a public debate. We had the arguments we were championing and refuting, expounding and criticising, to concentrate on. We were too busy keeping our own end up, whatever it might be, to worry too much about the presence of the audience. Performances became clearer and more decisive as the characters of the personages became more and more obvious and gained in assertiveness from the arguments they were putting forward. It became, to use Brecht's phrase, 'a boxing match of ideas'. We were primarily debaters, only secondarily actors – and most of us were more used to being the first than the second.

From a dramatherapy point of view, this change of mood, amounting almost to what Goffman calls a change of social frame within the play itself, was very important. It left us able to look at what we had being doing during the last hour-and-a-half in a critical way while still protected by the characters and plot of the play. During the half-hour or so after the audience had left, we settled down to explore in retrospect the territory we had journeyed through. What had the voyage been like? What had we ourselves felt like? Was the performance like the rehearsals had been? If not, what was

different about it? Most important of all, had the audience enjoyed it? And what about the audience!

'Wasn't it good when...'; 'I didn't know what to do, there wasn't anything I *could* do...'; 'Total disaster – it was *you* who got me out of that mess!'

This kind of theatre allows everyone taking part to assess the experience and to do so in the same kind of dramatic context – that of plays and players.

The important thing to notice from the point of view of this chapter is the possibility inherent in this approach for a theatrical model of research into dramatherapy. Within the process of theatrical rehearsal, performance and reflection, no one is obliged to acknowledge openly that their own feelings, ideas, fantasies, problems, difficulties and hang-ups are being worked with, or on, by the group. The focus is always on the play and the people in it, the audience and their reaction to it. Feelings, ideas and attitudes evoked by the play itself, however, may be discussed and the hidden nature of the emotions of the play's characters recognised and appreciated as an essential part of the rehearsal process. It is hard to 'get inside' a character without being brought face to face with whatever is 'inside' you because it is your capacity for feeling things that you will use in order to give your character life. Does this person I'm playing feel one thing and say another? Do I do this myself? Am I doing it now, I wonder? Is he or she aware of their real motives, their real needs and desires? Am I aware of mine? Certainly, there's something there that I can identify with, even if I am not immediately aware of doing so. As Marina Jenkyns puts it: 'A play can provide healing precisely because it provides a place to which the audience can bring the unconscious text of their lives, and by meeting the form and structure of the play, find new ways to shape their experience' (1996, p.72).

In the final part of the process comparisons may be made between how somebody felt about the play before, during and after the performance, about the play and about themselves and, more specifically, about themselves in the play. Disclosure happens naturally, without having to be forced into the open. In other words, the client actors take part in research into what exactly the effect of therapy has been and what the processes were that made it effective. This may seem natural and straightforward, except to those who have tried to involve clients in any kind of formal investigation into the way that dramatherapy 'works'. Certainly, when I included structures in my own previous research which had been specially designed to be measured or otherwise assessed, while still remaining authentically dramatherapeutic, I almost brought things to a standstill ('You're trying to test us, Roger'), so that

I had to remove them as discreetly as possible. Using the theatrical model, the clients are able to assess themselves and one another from inside the process – that is, without the sense of an alien presence intruding another set of ideas and expectations into the imaginative world that is emerging between and among those taking part within the group.

Certainly, if we want to understand the phenomena of dramatherapy, we must adopt models of research which are in harmony with the object of our study. If we are working with other people in order to bring about healing by means of the experience of being in relation, we have to be willing to involve our clients as partners in our research and to take up a position within, rather than without, the context we are examining. As Payne has said with regard to arts therapies research: 'A sole reliance on traditional [nomothetic] research approaches denies us access to the richness available in the process and other phenomena intrinsic to practice' (1993, p.33; see also Reason 1988; Reason and Rowan 1981). Dramatherapy, in particular, envisages the emergence of a special relational world in which there are multiple realities that can only be viewed holistically. However, this does not mean that the experience itself eludes systematic evaluation. It is, as Payne and Meekums suggest, a matter of replacing quantity with quality: 'Aspects of the phenomena are understood deeply because they are known within a context of our participation in the whole system, not as the isolated dependent and independent variables of experimental research' (Payne 1993, p.170). If we are to arrive at an understanding of what is actually taking place within a group, we must pay attention to realities that are continually changing and growing, in which we ourselves are involved and affected by our involvement, so that subject and object are transformed in the exchange. What has happened in the group can only be studied by the group, in terms of the group. Theatre therapy of the kind suggested by *The Frogs* presents us with a version of the conditions under which the group may be willing to look at itself and produce at least an interim report.

Reading List

Moustakas, C. (1990) *Heuristic Research: Design, Methodology and Applications.* London: Sage.

Moustakas, C. (1994) *Phenomenological Research Methods.* London: Sage.

A Research Repertoire

If we are to make sense of the claims made by different kinds of arts therapies research to represent the most effective and truthful ways of examining and understanding the phenomena they set out to study, we must look at their similarities as well as their differences. The first and most important thing they all share is a genuine concern to understand about life. This should never be overlooked or underestimated because it is powerful enough, in some cases (and not always the ones we might expect), to lead to the sharing of insights across epistemological boundaries. Shaun McNiff, whose research is art based, is encouraged in his rejection of traditional attitudes and assumptions with regard to research by the kind of advanced scientific thinking associated with Niels Bohr's quantum physics, which 'emphasises a mechanics of discontinuity as contrasted to the old mechanics of continuity' (McNiff 1998, p.46). He reminds us that science, like art, thrives on the creative and imaginative; we should not dismiss whole disciplines in our enthusiasm to state our own points of view as powerfully as possible, as 'disciplines influence and assist one another with ideas and themes that apply to the broader context of life' (p.47). Although art-based research strongly repudiates the reductionism implicit in what has become known as behavioural psychology, the need to relate art and science as ways of looking at life that are complementary rather than mutually exclusive still remains.

Certainly, there is evidence of this in the continuing interest shown by practitioners and researchers of all kinds – particularly those involved in researching the arts therapies – in deciding which research actually is research. The number of post-graduate university courses devoted to 'researching research' continues to grow steadily, while the problem of defining the concept in ways that allow a wider exchange of views and a

greater range of available expertise provides an increasingly popular theme for conferences.[1] Perhaps this is because the urge to carry out research has begun to affect people and groups previously unaffected by it, taking in a widening spectrum of jobs and professions. Ways of solving problems and procedures for putting the solutions into effect that were previously taken on trust and explained in terms of ideas and assumptions that had not been really closely examined – at least, not lately – began to seem to be crying out for some kind of appropriate research strategy. The subject of research has become more and more popular in places and among people who were previously unwilling to share their ideas with others, either because they did not consider it important or because they believed that other people's opinions on the subject were simply irrelevant. Nowadays, however, there is a much greater willingness to talk about this, and to go on discussing it, even though the presence of differing academic traditions inevitably makes discussion hard work.

It is extremely difficult to see how it could be anything else, considering the variety of purposes research can be put to and the close connection between the way we set about it and our reason for wanting to do it in the first place. I have suggested earlier in this book that the choice of a research approach may sometimes be decided by somebody's desire to demonstrate their skill in using a particular research technique. Much more pervasive is the effect of our regarding our own theoretical or philosophical understanding of what research actually is to decide our opinions about what it can properly be used for, so that we conclude that if the state of affairs to be investigated does not seem suited to the kind of approach we have given our allegiance to, it is, therefore, either unsuitable for research of any kind or can only be properly studied when the observed difficulties have been ruled out of court or systematically ignored – along, of course, with any need to preserve the original nature and identity of whatever it was that was being looked at.

There is no need for this kind of draconian tactic, however. Different research strategies, along with their philosophies, perform different functions and are, consequently, appropriate for different research problems. What is needed is understanding, tolerance and a willingness to share – and the courage to experiment with unaccustomed approaches to problem

1 Most universities now offer Post-Graduate Certificates in Research Methodology, Post-Graduate Diplomas (aimed at giving graduates experience with the research process before embarking on a Masters, MPhil or PhD) and an MA in Research.

solving, some of which may have been rejected before being properly examined and were certainly not entertained with anything approaching sympathy. Because it involves drawing conclusions about the relationship between two very different realities – our perception of experience and the way we codify our perceptions – research, even qualitative research, never really achieves the degree of accuracy we would like it to have. We are used to the idea that mathematical exactness is only won at the price of phenomenological distortion. But it is equally true that the kind of 'thick' description that qualitative approaches depend on may turn out to be equally frustrating as an index of the truth of the actual experience being examined – how can you come to a precise conclusion about the phenomenological nature of an experience which everyone involved has undergone and registered in his or her own uniquely personal way?

Research always involves a trade-off between two kinds of inaccuracy, numerical and experiential, corresponding to the imprecise nature of the fit between the way we think about life and life itself. This is the case whether we are scientists or artists. It is our own fault if we confine ourselves to being one or the other, refusing to see the world other than in terms of its capability to provide certain kinds of evidence in certain well-defined ways. The approaches to research described in this book are not simply alternative versions of the same activity, they regard life and the world in different ways. This is, however, precisely why they are so useful. Taken together, they provide us with a range of ways of increasing our understanding of what can be accurately understood and, perhaps, explained and of appreciating the wonder and fascination of things that evade this kind of understanding.

Each of the research approaches we have considered attempts to carry out a particular purpose. These can be summarised as follows:

- observing effects (quantitative research)
- recording experiences (qualitative research)
- understanding process (action research)
- demonstrating newness (art-based research).

In different ways, and to varying extents, all four approaches do all of these things. I have distinguished them like this in order to draw attention to the underlying intention that characterises each of them, making them, for practical purposes, significantly different from one another.

If the main purpose of a piece of research is to decide whether or not a certain course of action has an effect on a particular state of affairs which

would not occur if that course of action were not followed, the answer is only likely to be convincing if it invites some kind of measurement. Quantitative research is basically outcome research. Its use is to establish cause-and-effect relationships so that a reasonable claim may be made as to whether something 'works' or not. Obviously, this is important information for those whose job is to cost particular programmes of action – they are likely to take this kind of research seriously because it is in their interest to do so.

Whereas quantitative research concentrates on looking for evidence that something has a measurable effect upon something else, qualitative research extends this by wanting to know how this happens. This is sure to increase the researcher's understanding of processes of change but, often, can only be achieved at the cost of being willing to be less precise about why. Qualitative research is process research, recommended to those who are concerned to examine complex situations in the reality of their complexity. It is possible to do this in ways that respect the rules governing cause-and-effect linkages, however.

In practitioner research the qualitative approach is extended and deepened by the researcher's refusal to leave him or herself out of the research equation, both as researcher and researched, and his or her consequent willingness to use his or her own experiences as valid experiential data. This is action research. It is an effective way of gaining in-depth experiential knowledge of a research context.

Art-based research could be called creativity or creation research. Because of its unwillingness to translate the language of artistic experience into any other kind of code, claiming that the loss of meaning involved in doing this actually destroys the whole purpose of research, art-based research explores experiential transformations without quantifying them. In this sense it is a work of art in itself, but one that is recognisably different from its original form and aesthetically unique.

Another way of putting this would be to say that quantitative research seeks to demonstrate, qualitative to describe (or explain by describing), practitioner-involved to experience (and explain) and art-based to explore and document in an appropriate language (i.e. that of art). In fact, they are all about demonstration. They merely go about it in different ways.

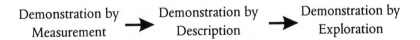

Demonstration by Demonstration by Demonstration by
Measurement Description Exploration

The underlying aim of all research is clarification. As we have seen, some things are easier to clarify than others and if the wrong kind of research is used – the wrong theory, as this is expressed in the wrong method – the result is bound to show some kind of distortion, a process of obfuscation not clarification, one which cannot legitimately be described as research at all. The subject matter of arts therapies research is easily distorted – art being the natural symbol for things that are otherwise inexpressible. For this reason, arts therapists can be expected to favour methods which avoid equating efficiency with precision of measurement, which is the most obvious source of mismatches between message and medium in experiential research. In fact, they are bound to be drawn to what is scientifically vague but artistically expressive. If there is any choice in the matter, they will almost certainly choose practitioner or art-based research rather than quantitative research.

However, it is important to remember what quantitative research is for and, therefore, probably does best. The first piece of research in this book attempted to make a single basic point – that dramatherapy is effective as a way of reducing thought disorder. However eager we are to preserve the integrity of the medium within which a therapeutic approach functions, we still need to demonstrate that it does function. There is no excuse for simply not trying to find out in what areas arts therapies produce results – or, indeed, if they actually produce results at all! There will always be a place in arts therapies research – or, indeed, in any sphere of research at all – for conclusions that can be drawn within the language of mathematics – in other words, for carefully controlled quantitative experiments. There is no need to regard outcome research of this kind as an unfortunate compromise forced on the arts therapies by the sheer necessity to attract funding for more congenial investigations. After all, we ourselves need to have this kind of evidence so that our intervention can produce demonstrable results – ones we can use to convince even those who do not 'speak our language'. In the same way, we need to be able to reassure ourselves, as well as them, that the conclusions we draw in qualitative research about the existence of causal relationships between the various factors affecting the experiences of the people we are studying (including our own, perhaps) hold together in logical, scientifically consistent ways, that they are grammatically correct according to the basic language of experimental research.

Except, of course, for those situations in which we are really not concerned with traditional experimental approaches at all and aim at creating new ways of seeing which are also new modes of being for those involved.

Here it may be that scientific language will not help us all that much. In fact, we need to have several different languages at our command, not just one, however congenial we may happen to find it. As a dramatherapist put it to me, this is a situation when we might consider having at least two kinds of research in our repertoire – one for ourselves and the other for our audience. Why only two? Why not as many as we can lay our hands on? The aim of this book has been to describe some basic types of research as they apply to the arts therapies and have actually been used by arts therapists. Because this is research, the conclusions drawn, however passionately defended, are always provisional – in other words, they are waiting to be proved false or at least demonstrated as inaccurate. After all, this is what the experimental approach is all about.

Appendix

Robert Landy: Art-Based Academic Research

Robert Landy (1993) draws attention to the existence of 'a theatrical archetype system' whose purpose is, first of all, to distinguish the types of role from which Western theatre is constructed and then to 'establish connections among repeated role types and to uncover in theatrical form a system of making sense of the complexities of existence as they are revealed through character' (p.163). In order to examine the part played by personal and social role-playing in human drama (in both its self-conscious and unselfconscious forms) and the way this is embodied in theatre, he has devised a 'taxonomy of roles' divided into various 'domains': cognitive, affective, social, spiritual, aesthetic. In his book he examines 84 theatrical role types from 'child' (1) to 'dreamer' (84) in order to demonstrate the all-embracing nature of the theatrical role repertoire and its ability to take account of the breadth of human experience: 'I am tempted to conclude that role is essentially an unencumbered concept, definable in such simple terms as "the qualities of a character or type in dramatic literature". Yet, in working across disciplines and attempting in part to create a system that addresses psychological dysfunction and everyday existence, I have found that this simple concept transcends its clear boundaries' (p.9).

Obviously, this mammoth task involved a great deal of research of an academic kind. At the same time, however, because Landy's approach is unquestionably art based and his concept of theatrical roles describes the milieu in which, as a dramatherapist, he is personally involved (drama being, so to speak, 'the air he breathes'), it would be inappropriate not to mention his work in a book about arts therapies research. It is certainly true that, as Shaun McNiff (1998) says, 'We have not done enough in creative arts therapies to incorporate the research methods of history and the other humanities' (p.105).

References

Bannister, D. (1960) 'Conceptual structure in thought-disorder schizophrenia.' *Journal of Mental Science 106*, 1230–1249.

Bannister, D. (1962) 'The nature and measurement of schizophrenic thought disorder.' *Journal of Mental Science 108*, 824–842.

Bannister, D. and Fransella, F. (1966) 'A grid test of schizophrenic thought-disorder.' *British Journal of Social and Clinical Psychology 5*, 95–102.

Bannister, D. and Fransella, F. (1971) *Inquiring Man*. Harmondsworth: Penguin.

Bannister, D., Adams-Webber, J.R., Penn, W.I. and Radley, A.R. (1975) 'Reversing the process of thought disorder: A serial validation experiment.' *British Journal of Clinical Psychology 14*, 169–180.

Blatner, A. (1977) *Acting-In*. London: Free Association Books.

Buber, M. (1958) *I and Thou*. Edinburgh: T & T Clark.

Burr, V. and Butt, T. (1992) *Invitation to Personal Construct Psychology*. London: Whurr.

Cheshire, N.M. (1975) *The Nature of Psychodynamic Interpretation*. London: Wiley.

Coombs, C. (1964) *A Theory of Data*. New York: Wiley.

Delbecq, A.L., Van de Ven, A.H. and Gustafson, D.H. (1975) *Graph Techniques for Programme Planning*. Chicago: Scott Foresman.

Duggan, M. and Grainger, R. (1997) *Imagination, Identification and Catharsis in Theatre and Therapy*. London: Jessica Kingsley Publishers.

Edwards, D. (1989) 'Five years on: Further thoughts on the issue of surviving as an art therapist.' In T. Dalley and A. Gilroy (eds) *Pictures at an Exhibition: Selected Papers on Art and Art Therapy*. London: Tavistock.

Edwards, D. (1993) 'Why don't arts therapists do research?' In H. Payne (ed) *One River, Many Currents: Handbook of Inquiry in the Arts Therapies*. London: Jessica Kingsley Publishers.

Eisner, E.W. (1985) *The Art of Educational Evaluation*. London: Falmer.

Emunah, R. (1983) 'Drama therapy with adult psychiatric patients.' *The Arts in Psychotherapy 10*, 77–89.

Epting, F. and Landfeld, A.W. (1985) (eds) *Anticipating Personal Construct Psychology*. Lincoln: University of Nebraska Press.

Flowers, J.V. (1975) 'Simulation and role-playing methods.' In F.H. Kanfer and A.P. Goldstein (eds) *Helping People Change*. Oxford: Pergamon.

Freud, S. (1917) *Mourning and Melancholia, Standard Edition, Vol.14*. London: Hogarth Press and Institute of Psycho-Analysis.

George, A.L. and McKeoun, T.J. 'Case studies and theories of organisational decision making.' In *Advances in Information Processing in Organizations 2*, 21–58.

Gersie, A. (1996) (ed) *Dramatic Approaches to Brief Therapy*. London: Jessica Kingsley Publishers.

Geertz, C. (1973) *The Interpretation of Cultures*. London: Hutchinson.

Goffman, E. (1990) *The Presentation of Self in Everyday Life*. Harmondsworth: Penguin.

Grady, K.E. and Wallston, B.S. (1988) *Research in Health Care Settings*. London: Sage.

Grainger, R. (1987) 'Evaluation in Dramatherapy.' In D. Milne (ed) *Evaluating Mental Health Practice*. London: Croom Helm.

Grainger, R. (1990) *Drama and Healing*. London: Jessica Kingsley Publishers.

Grainger, R. (1995) *The Glass of Heaven: The Faith of the Dramatherapist*. London: Jessica Kingsley Publishers.

Hargie, O.D.W. and Gallagher, M.S. (1992) 'A comparison of the core conditions of client-centred counselling in real and role-play counselling episodes.' *Counselling*, August, 153–156.

Irwin, C., Levy, P. and Shapiro, M. (1972) 'Assessment of drama therapy in a child guidance setting.' *Group Psychotherapy and Psychodrama 24*, 105–116.

Jenkyns, M. (1996) *The Play's the Thing*. London: Jessica Kingsley Publishers.

Jennings, S. (1990) *Dramatherapy with Families and Groups: Waiting in the Wings*. London: Jessica Kingsley Publishers.

Jennings, S. (ed) (1987) *Dramatherapy: Theory and Practice for Teachers and Clinicians*. London: Croom Helm.

Jennings, S. (ed) (1992) *Dramatherapy: Theory and Practice 2*. London: Routledge.

Jennings, S. (1998) *Introduction to Dramatherapy: Theatre and Healing*. London: Jessica Kingsley Publishers.

Jennings, S. (1999) *Introduction to Developmental Playtherapy: Playing and Health*. London: Jessica Kingsley Publishers.

Johnson, D.R. (1982) 'Developmental approaches in drama therapy.' *The Arts in Psychotherapy 9*, 183–9.

Jones, P. (1995) *Drama as Therapy: Theatre as Living*. London: Routledge.

Jung, C.G. (1968) *Analytical Psychology*. London: Routledge and Kegan Paul.

Kelly, G. (1955) *The Psychology of Personal Constructs*. NY: Norton.

Kelly, G. (1963) *A Theory of Personality*. NY: Norton.

Kersner, M. (1990) (ed) *The Art of Research*. Proceedings of the 2nd Arts Research Conference, London, City University.

King, G., Keohane, R.O. and Verba, S. (1994) *Designing Social Inquiry*. Princeton: Princeton University Press.

Landy, R. (1993) *Persona and Performance*. London: Jessica Kingsley Publishers.

Landy, R. (1986) *Drama Therapy: Concepts and Practices*. Springfield, IL: Thomas.

Landy, R. (1982) 'Training the drama therapist – A four-part model.' *Arts of Psychotherapy 9*, 91–99.

Leunig, M. (1991) *The Prayer Tree*. Oxford: Lion.

Lidz, T. (1968) 'The family, language and the transmission of schizophrenia.' In D. Rosenthal and S. Kelly (eds) *The Transmission of Schizophrenia*. London: Pergamon.

Lidz, T. (1975) *The Origin and Treatment of Schizophrenic Disorders*. London: Hutchinson.

Mackewn, J. (1977) *Developing Gestalt Counselling*. London: Sage.

Martin, P. (1981) 'A garbage can model of the psychological research process.' *American Behavioural Scientist 25*, 131–151.

Maxwell, J.A. (1996) *Qualitative Research Design*. London: Sage.

Maxwell, J.A. and Miller, B.A. (1996) *Categorisation and Contextualisation in Qualitative Data Analysis*. Unpublished manuscript.

May, R. (1975) *The Courage to Create*. London: Collins.

Mazer, R. (1982) 'Drama therapy for the elderly in a day centre.' *Hospital and Community Psychiatry 33*, 577–579.

McNiff, S. (1998) *Art-based Research*. London: Jessica Kingsley Publishers.

Meekums, B. and Payne, H. (1993) 'Emerging methodology in dance movement therapy research.' In H. Payne (ed) *One River Many Currents: Handbook of Inquiry on the Arts Therapies*. London: Jessica Kingsley Publishers.

Milne, D. (ed) (1987) *Evaluating Mental Health Practice*. London: Croom Helm.

Milner, M. (1952) 'Aspects of symbolism in the comprehension of the not-self.' *International Journal of Psychoanalysis 33*, 181–195.

Mitchell, S. (ed) (1996) *Dramatherapy: Clinical Studies*. London: Jessica Kingsley Publishers.

NUD IST (1997) QSR 4, NUD IST. London: Sage.

Parlett, M. (1983) 'Illuminative evaluation.' In *International Encyclopaedia of Education and Research Studies, 15*. Oxford: Pergamon.

Parlett, M. and Deardon, G. (eds) (1977) *The Illuminative Evaluation in Higher Education*. Los Angeles, California: Pacific Sounding Press.

Payne, H. (ed) (1993) *Handbook of Inquiry in the Arts Therapies: One River, Many Currents*. London: Jessica Kingsley Publishers.

Perls, F.S., Hefferline, R.F. and Goodman, P. (1973) *Gestalt Therapy: Excitement and Growth in Human Personality*. Harmondsworth: Penguin.

Platt, J. (1988) 'What can case studies do?' In R.G. Burgess (ed) *Studies in Qualitative Methodology; Conducting Qualitative Research*. London: Jai.

Reason, P. (1988) *Human Inquiry in Action*. London: Sage.

Reason, P. and Rowan, J. (eds) (1981) *Human Inquiry: A Sourcebook for New Paradigm Research*. Chichester: Wiley.

Reinharz, S. (1981) 'Implementing new paradigm research: a model for training and practice.' In P. Reason and J. Rowan (eds) *Human Inquiry: A Sourcebook for New Paradigm Research*. Chichester: Wiley.

Robson, C. (1973) *Experiment, Design and Statistics in Psychology*. Harmondsworth: Penguin.

Robson, C. (1993) *Real World Research*. Oxford: Blackwell.

Rogers, P. (1993) 'Research in music therapy with sexual abused clients.' In H. Payne (ed) *One River, Many Currents: Handbook of Inquiry in the Arts Therapies*. London: Jessica Kingsley Publishers.

Schattner, G. and Courtney, R. (eds) (1981) *Drama in Therapy, Vol. 2*. New York: Drama Book Specialists.

Sheridan, C.L. (1973) *Methods in Experimental Psychology*. New York: Holt Rinehart and Winston.

Spencer, P.G., Gillespie, C.R. and Ekisa, E.G. (1983) 'A controlled comparison of the effects of social skills training and remedial drama on the conversational skills of chronic schizophrenic inpatients.' *British Journal of Psychiatry 143*, 165–172.

Valente, L. and Fontana, D. (1993) 'Research into dramatherapy theory and practice.' In H. Payne (ed) *One River, Many Currents: Handbook of Enquiry in the Arts Therapies*. London: Jessica Kingsley Publishers.

Winnicott, D.W. (1971) *Playing and Reality*. London: Tavistock.

Subject Index

Author Index